A BEGINNER'S GUIDE TO
Modern Calligraphy
AND
Brush Pen Lettering

Learn to Create Beautiful Hand Lettering
for Invitations, Cards, Journals and More!

Maki Shimano

TUTTLE Publishing

Tokyo | Rutland, Vermont | Singapore

contents

LESSON 1 Typeface Variations

LESSON 2 Modern Calligraphy Design

Note Please only print and reproduce the practice sheets included in this book for personal use. The sample typefaces and designs are for personal enjoyment only. Digitalization of the typefaces, repurposing for commercial designs, selling of goods or kits, operating a school, and listings on various online sales sites or auctions for profit are all prohibited by copyright law. Please also refrain from exhibiting in art shows or hosting workshops using parts of this book.

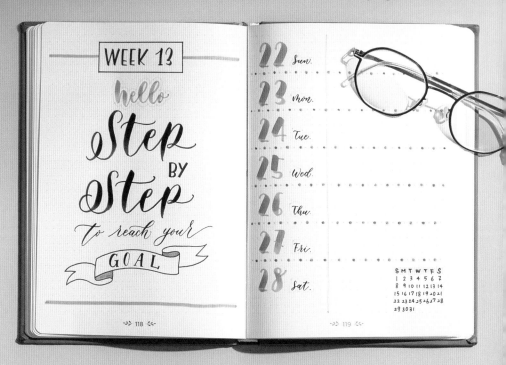

Bullet Journal
▶ Instructions on pages 116–117

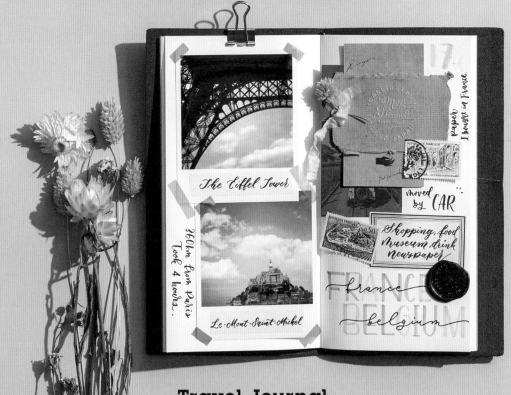

Travel Journal
▶ Instructions on pages 120–121

Scrapbook
▶ Instructions on pages 118–119

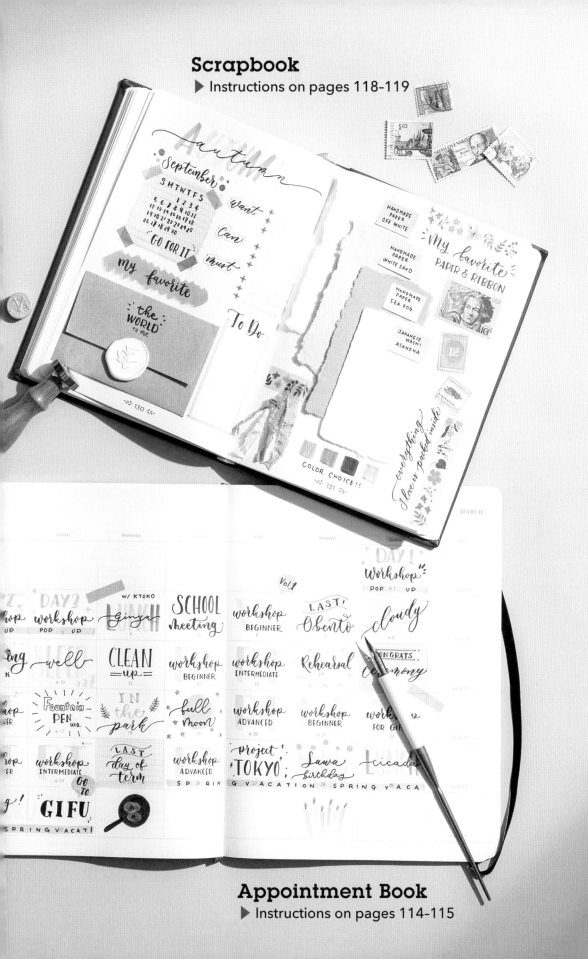

Appointment Book
▶ Instructions on pages 114–115

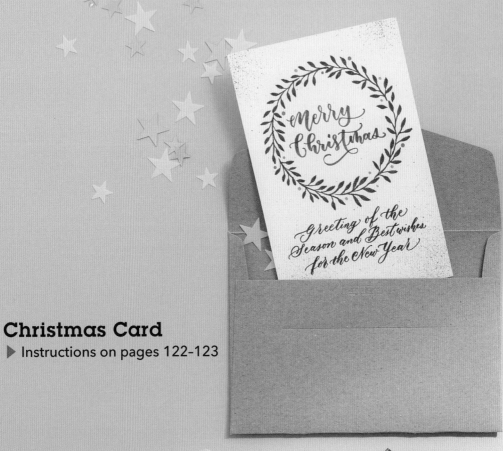

Christmas Card
▶ Instructions on pages 122-123

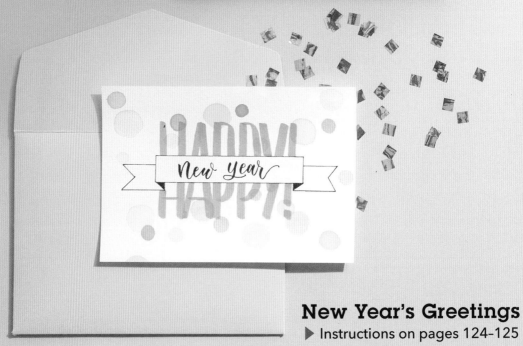

New Year's Greetings
▶ Instructions on pages 124–125

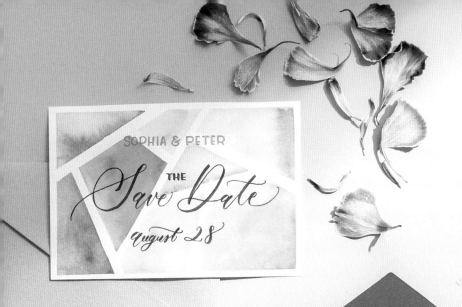

Save-the-Date Card
▶ Instructions on pages 128–129

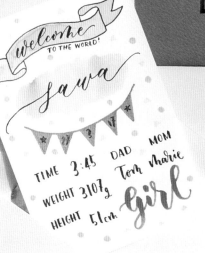

Birthday Card
▶ Instructions on pages 126–127

Birth Announcement
▶ Instructions on pages 130–131

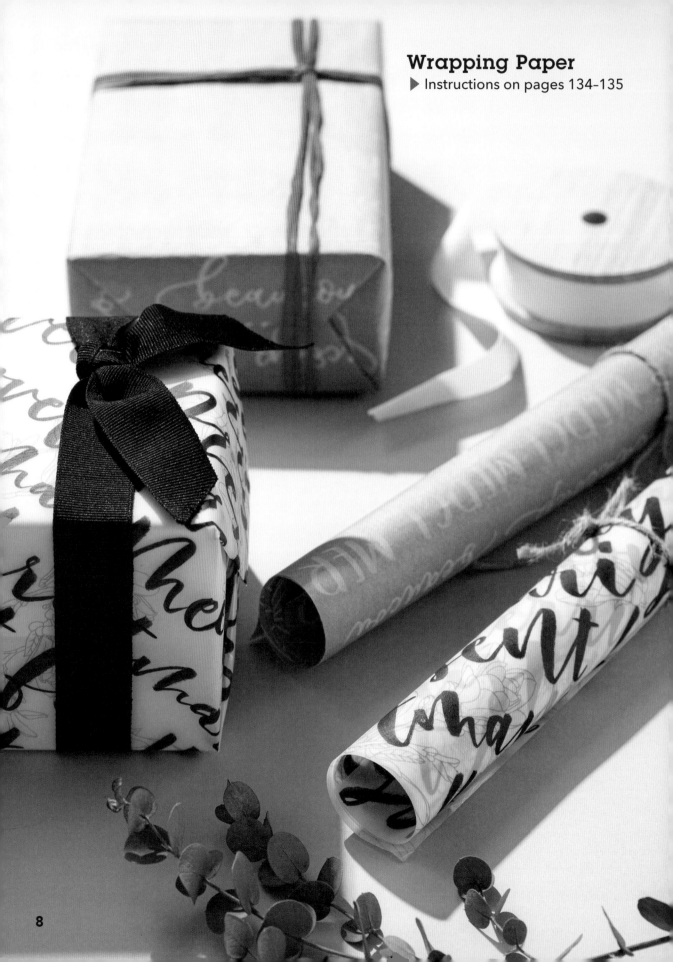

Wrapping Paper

▶ Instructions on pages 134–135

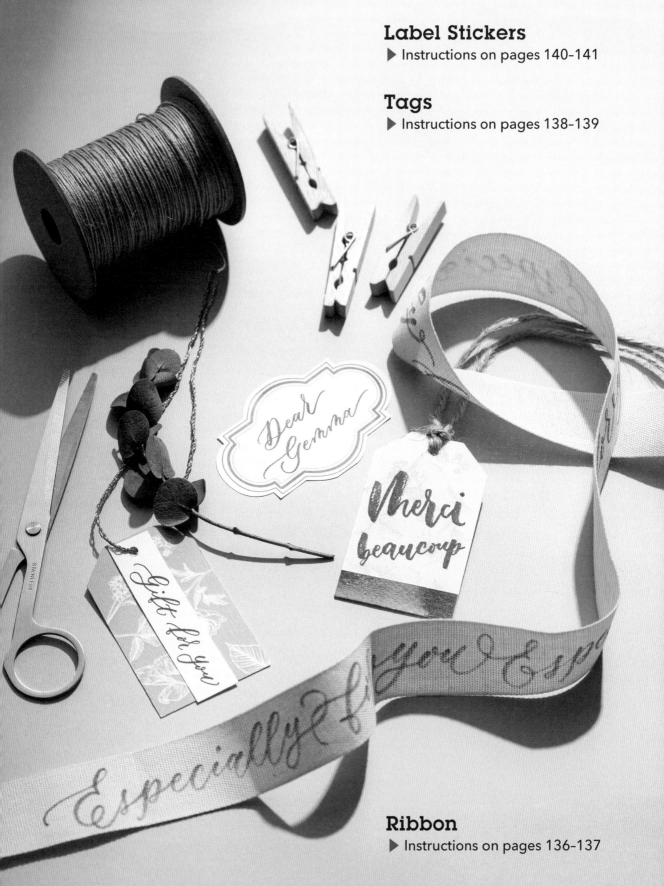

Label Stickers
▶ Instructions on pages 140-141

Tags
▶ Instructions on pages 138-139

Dear Gemma

Merci beaucoup

gift for you

Especially for you

Ribbon
▶ Instructions on pages 136-137

introduction

Why I Wrote This Book

In 2013, the world of modern calligraphy, which was becoming popular mainly in the US, caught my attention. The first thing I was drawn to was the world of the metal-nibbed "dip pen," which is used to write delicate, flowing, elegant words. At the time, being in the wedding industry, I thought that the modern, evolving and diverse aspects of contemporary weddings could become even more wonderful if combined with the beautiful world of modern calligraphy.

Upon starting, I realized that the world of modern calligraphy is vast. Beyond the traditional nibbed pen, there's also the brush pen—the use of which being the focus of this book—and even digital calligraphy. Modern calligraphy is greater than the sum of its pen-and-paper parts, and it is loved globally as a unique style of expression.

Speaking of brush pens, they are an indispensable tool for the Japanese, commonly used for composing congratulatory or condolence messages, or for writing letters to someone. The appeal of brush pens is the flexibility of the brush tip, which allows one to write script as if painting a picture—the basis for modern calligraphy.

With just a favorite pen and paper at hand, you can immediately get started with this exciting hobby. I hope that you will incorporate the joy of modern calligraphy and brush pen lettering into your daily life.

— Maki Shimano

Modern Calligraphy

What is Modern Calligraphy?

Modern calligraphy is a new style of script that emerged after the year 2000. While it utilizes some tools and techniques from traditional calligraphy, it emphasizes expressing letters in a more varied and free manner.

The application of modern calligraphy is not limited to just the traditional pens with metal nibs. It can be created through the use of brush pens, felt-tip pens, styluses for digital applications and even brushes usually used for painting. The letters are written as if drawing a picture.

Modern calligraphy breaks the bounds of tradition, pushing the expression of individuality and aesthetic sense to the forefront. This appeals to more than just those aiming for a professional look for their handwriting—anyone who feels inclined can easily take up the brush pen and begin writing script, which is proof of the casual charm of this profitable hobby.

Brush pens are easily available, making them the perfect tools for decorating cards, gift wrapping, journals, appointment books and more.

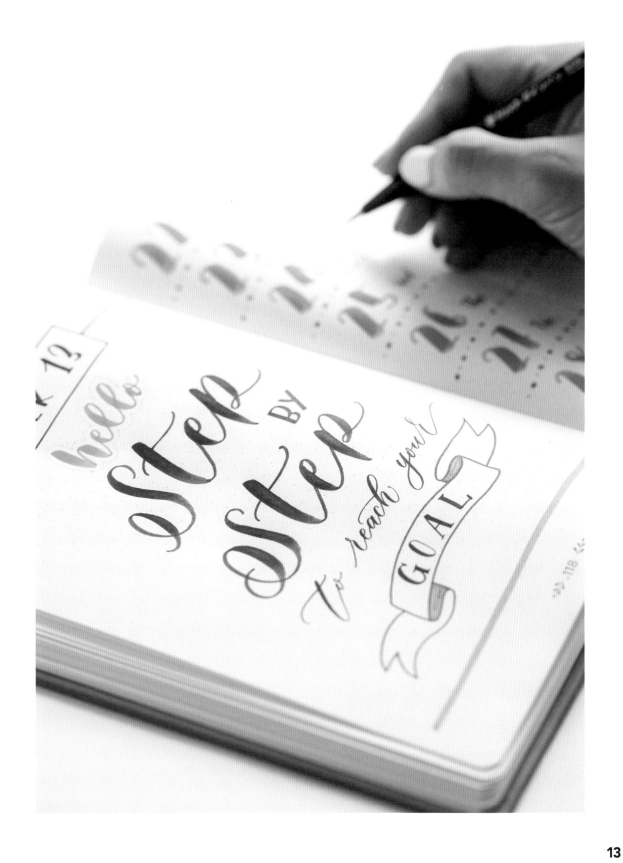

The Brush Pens Used in This Book

The tips of the pens shown on the facing page have a moderate flexibility, allowing for a natural variation in line thickness not unlike what can be achieved when writing with a "sign pen" (the Japanese term for felt-tip pens designed for writing). They effortlessly imbue the words you write with expressive letters and graceful lines. They're easy to manipulate even for beginners, and any one of them is suitable for practicing the modern calligraphy presented in this book.

The Fude Touch Brush Sign Pen (by Pentel)

Useful Tools to Have

Introducing handy tools that are useful when practicing basic lines and letters. Everything can be obtained from thrift stores or stationery shops. You don't need to go out of your way to buy them; you can substitute with what you have on hand.

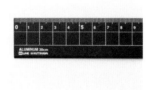

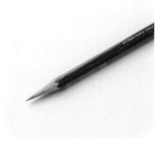

Paper
Convenient and easy-to-write-on copier paper, and tracing paper which can be placed over a guide sheet for tracing.

Ruler
Used when drawing guide lines. If it has grid markings, it's convenient for drawing parallel and vertical lines.

Pencil
Used when sketching. A mechanical pencil can also be used as a substitute. The key is to write as lightly as possible.

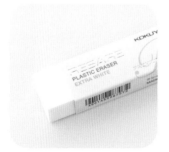

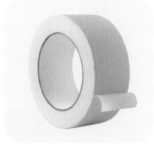

Eraser
Used to erase pencil sketches, marks and lines. Make sure the ink has dried completely before erasing carefully.

Masking Tape
Essential for temporarily holding practice sheets and tracing paper in place. Also used to protect areas where you don't want to apply color.

Types of Brush Pens

Even when we narrow the discussion down to just brush pens, there's a wide variety to choose from, ranging from hard-tip types similar to fountain pens to those with longer brush-like tips reminiscent of traditional calligraphy brushes. As each type has a different character, it's worth trying out various kinds.

Fude Makase Hard Tip & Ultra Fine (Pilot)

Fudenosuke Hard Tip (Tombow)

Keichou Sign Pen (Pentel)

Fude Touch Brush Sign Pen (Pentel)

Disposable Brush Sign Pen Medium (Zebra)

Fudegokochi Ultra-fine (Kuretake)

Shunpitsu Pocket Brush, Firm (Pilot)

Art Brush (Pentel)

Sai ThinLINE Ultra-fine Brush Pen (Akashiya)

Stroke Practice

Most letters are composed of a combination of multiple strokes. To write letters that are well-balanced and beautiful, it is essential to practice the basic strokes many times.

What is a stroke?

A stroke refers to the movement of the pen. Fundamentally, it consists of combinations of upward and downward movements. By controlling the pressure on the pen, creating variations in the weight of the stroke, a range of expressions emerge.

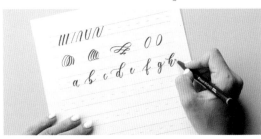

TIP 1
Practice Method

Place tracing paper over an enlarged copy of the reference sheet (pages 55 and onward), and secure it with masking tape. Then, trace over the letters. Tracing while being cognizant of the order of the strokes in the reference is the first step to beautiful handwriting.

TIP 2
How to Position the Paper

Adjust the angle of the paper to match the slant of the letters you're writing. If you're right-handed, tilt the paper slightly counterclockwise; if you're left-handed, tilt it clockwise. This will make writing easier.

TIP 3
How to Hold the Pen

The way you hold the pen is the same as holding a ballpoint or sign pen. As you change the pressure while writing, if you hold the pen too horizontally, it becomes hard to write thin lines, and if you hold it too vertically, it becomes difficult to write thick lines.

Basic Strokes

Before you begin writing modern calligraphy, let's go over the basic strokes you'll want to master. This practice is useful as a warm-up before writing letters.

DOWN STROKE

1. Apply pressure to the pen as you place it on the paper.
2. Without changing the pressure, draw a line straight downward.
3. Ensure that the line does not waver or get thicker midway. Maintain consistent pressure throughout.

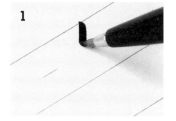 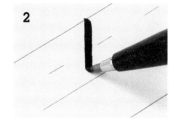 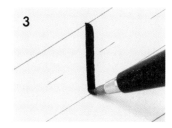

UP STROKE

1. Without applying much pressure, touch the tip to the paper.
2. With the same pressure, move it from the bottom to the top.
3. It's best to move it slowly and gently, but as you get used to it, increasing the speed makes it easier to write.

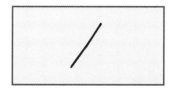

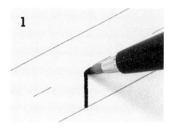 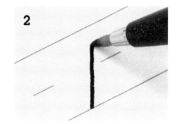

OVERTURN STROKE

1. Without applying much pressure, move the tip from the bottom to the top in an up stroke.
2. Gradually increase pressure as you gently curve.
3. Without changing the pressure, continue writing downward in a down stroke.

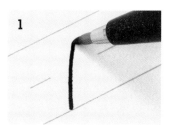 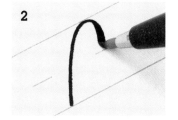

UNDERTURN STROKE

1. Apply pressure for a downward stroke, drawing a straight line.
2. Gradually ease the curve and slowly release the pressure.
3. Continue without applying much pressure and gently make an upward stroke.

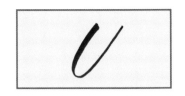

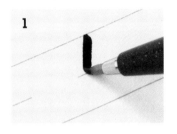 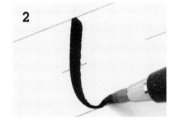 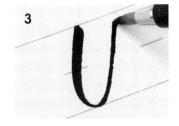

COMPOUND CURVE

1. Make an upward stroke without applying much pressure.
2. Gently curve, then slowly add pressure for a downward stroke.
3. Ease the curve, gradually release the pressure, and finish with an upward stroke.

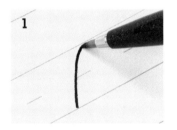 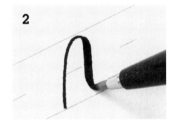 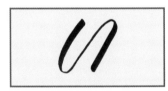

REVERSE COMPOUND CURVE

1. Apply pressure for a downward stroke.
2. Gently curve and slowly transition to an upward stroke with less pressure.
3. Ease into another curve, gradually increase the pressure, and finish with a downward stroke.

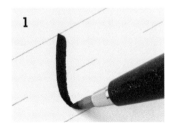 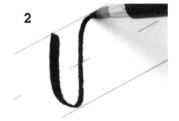

ASCENDER LOOP

1. Without applying much pressure, use the tip of the pen for an upward stroke.
2. Create a counterclockwise loop, slowly increasing pressure.
3. Continue without changing the pressure and connect with a downward stroke.

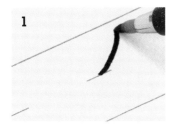
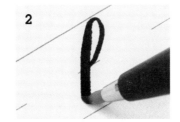

DESCENDER LOOP

1. Apply pressure for a downward stroke.
2. Create a clockwise loop and gradually release the pressure.
3. Write gently with an even line and finish with an upward stroke.

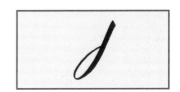

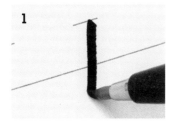
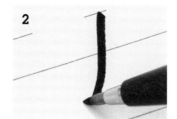
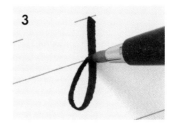

OVAL

1. Gently touch the pen tip to the paper, and then create a curving counterclockwise line while gradually increasing the pressure.
2. Continue with a downward stroke, easing the curve and releasing pressure.
3. Connect back at the starting point.

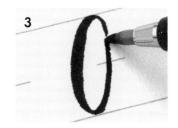

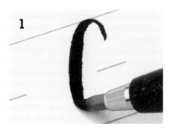
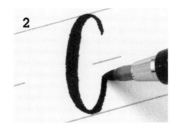
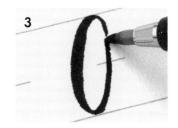

REVERSE OVAL

1. Gently touch the pen tip to the paper, and then create a curving clockwise line while slowly increasing the pressure.
2. Continue with a downward stroke.
3. Ease the curve, release pressure gradually, and connect back at the starting point.

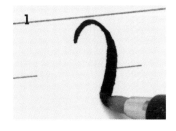 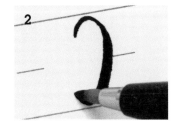 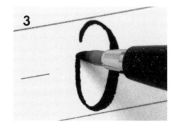

SPIRAL

1. Alternate between upward and downward strokes, drawing clockwise circles.
2. Maintain consistent pressure and spacing as you repeat.
3. Gradually draw smaller circles.

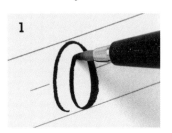 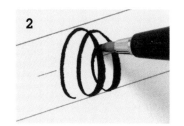 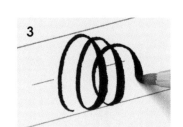

FIGURE EIGHT

1. Gently touch the pen tip to the paper, make a curved line, and then slowly increase the pressure to create a loop.
2. Maintain consistent pressure and spacing as you repeat.
3. Gradually make smaller loops.

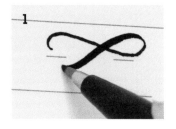 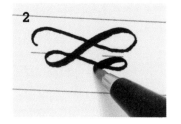

Lesson 1

Typeface Variations

Shirahana

———

DESIGNED BY
Maki Shimano

UPPERCASE LETTERS

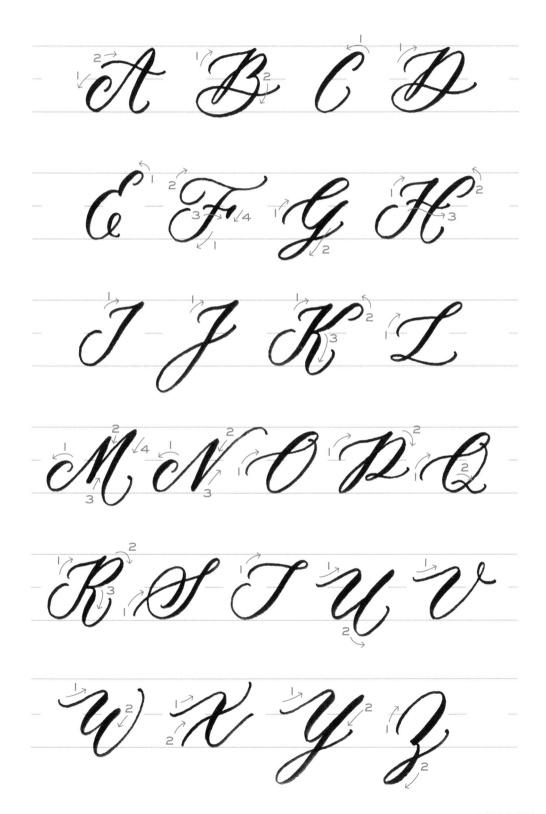

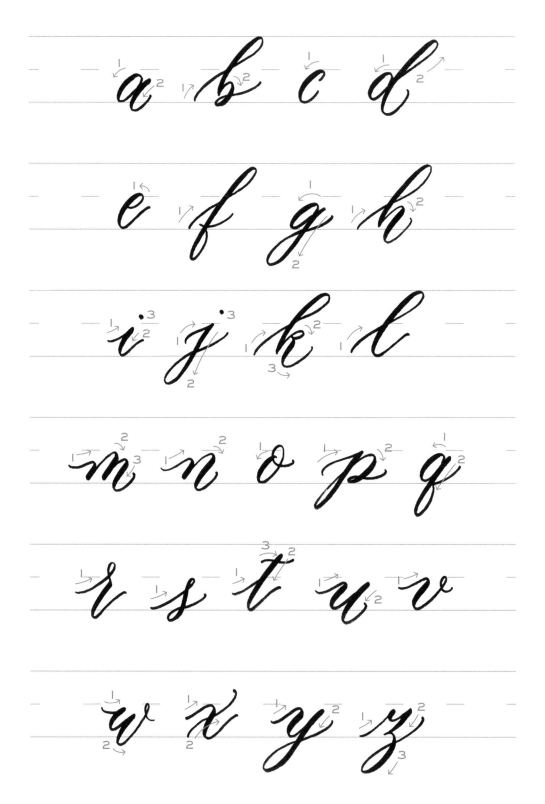

NUMBERS and SYMBOLS

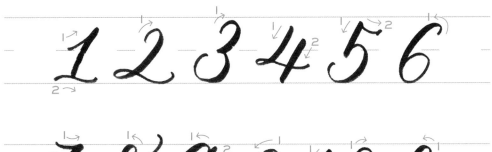

Writing Tips

Be careful not to leave too much space between the first and second downstrokes. If it's too wide, the finished letter will be horizontally elongated.

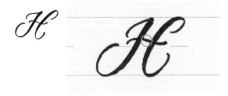

The key is to write the first upstroke as slanted as possible. If it's not slanted enough, the letter will stand straight up.

Start by drawing an oval, and then extend the line slightly outward with an upstroke and gradually increase pressure, crossing it with a downstroke.

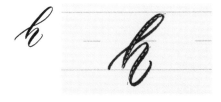

Write the downstroke with a gentle curve. Placing the second downstroke slightly inside creates a balanced finish.

Delica

DESIGNED BY
Maki Shimano

UPPERCASE LETTERS

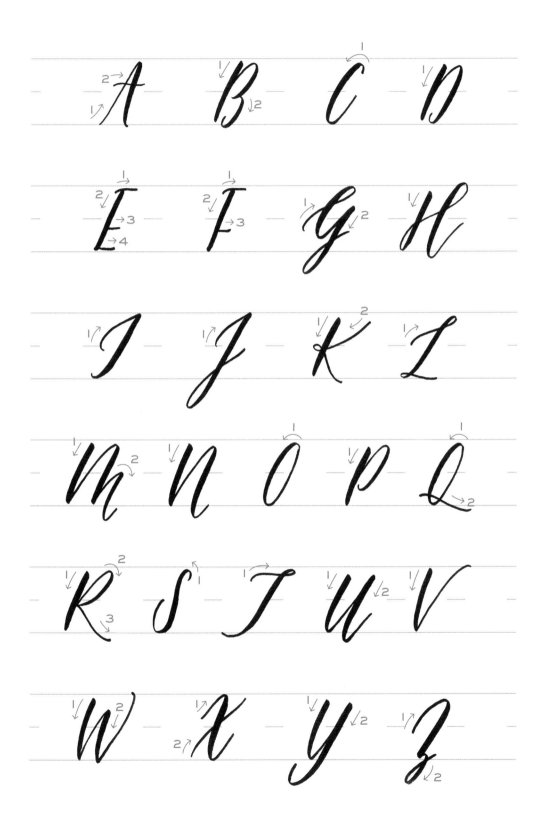

LOWERCASE LETTERS

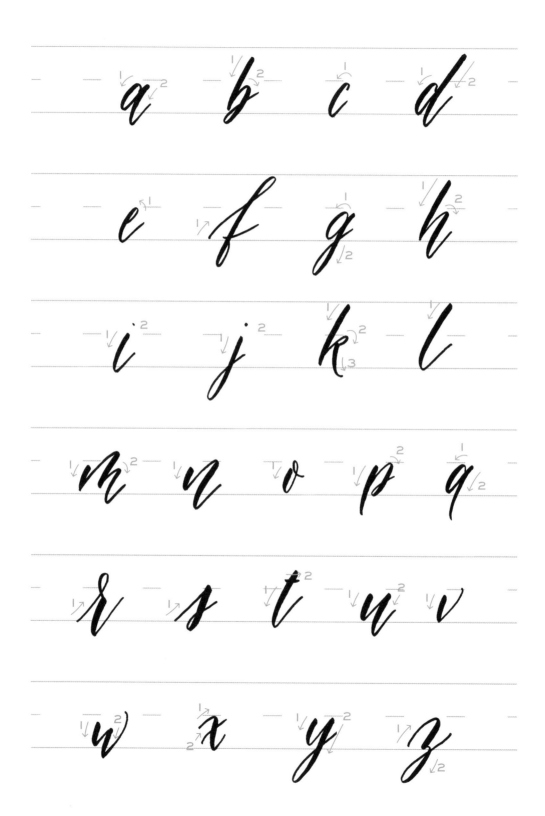

NUMBERS and SYMBOLS

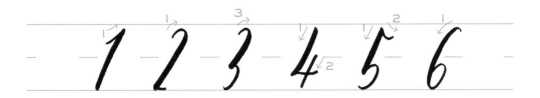

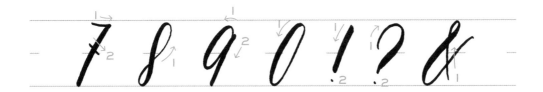

Writing Tips

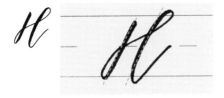

The letter "H" in this font is written in one continuous stroke. Make sure the two downstrokes are parallel, and write rhythmically.

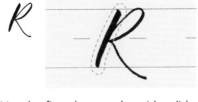

Write the first downstroke with solid pressure. By releasing the pressure afterward, you can give the letter a dynamic look.

Write the first downstroke straight, and the following one slightly inward. Finish by releasing the pressure.

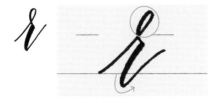

Start with an upstroke that forms a relatively large loop. This loop is crucial in defining the shape. The final curve should be sharp.

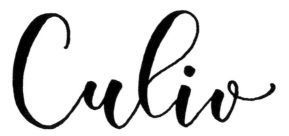

Culio

DESIGNED BY

Maki Shimano

UPPERCASE LETTERS

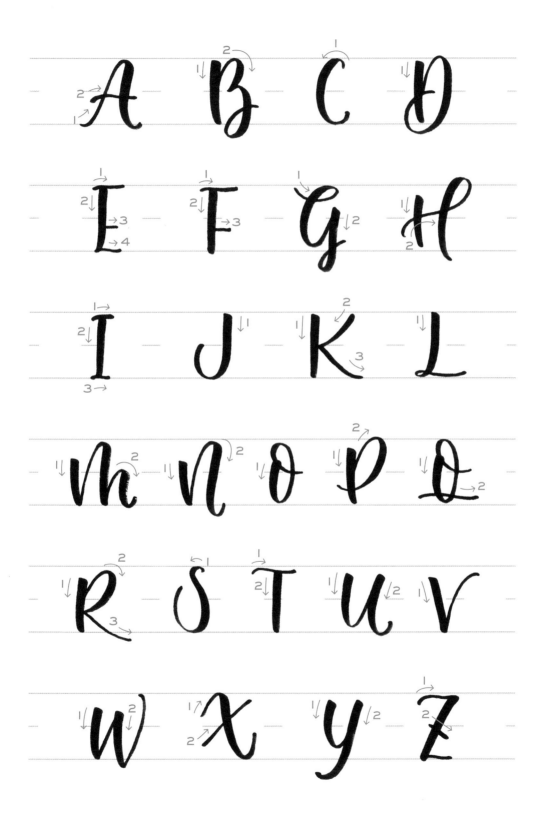

LOWERCASE LETTERS

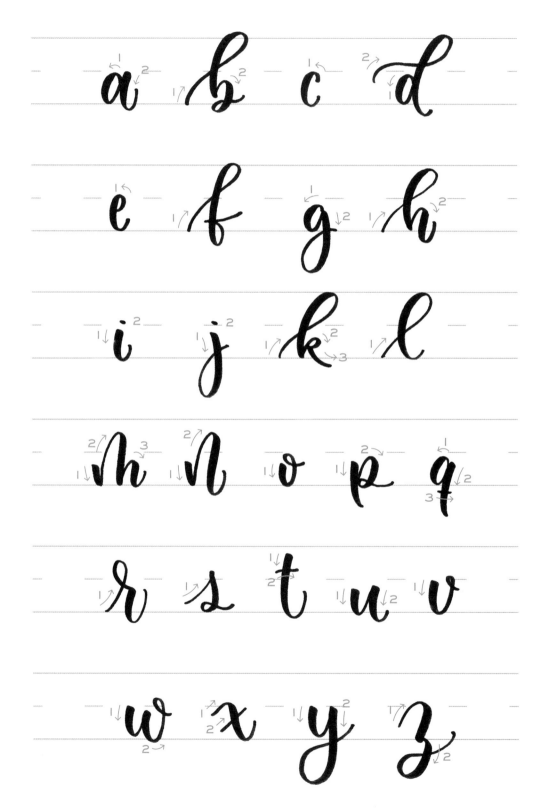

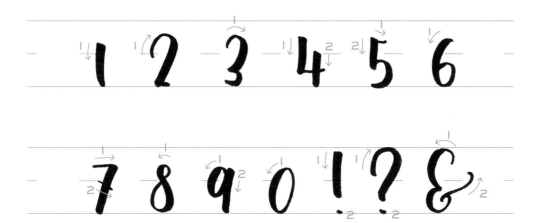

Writing Tips

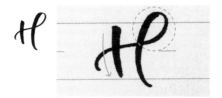

The first downstroke should be made curving slightly inward. When drawing the loop, make it round and a bit larger.

Draw an oval, and then connect it with a downstroke that has a bulge. The final upstroke's loop shouldn't be too large.

Start by drawing a large ascender loop, followed by a small "R." Release pressure gently on the final downstroke.

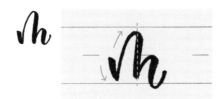

The first downstroke should curve inward. Tilt the following upstroke to the right, and then emphasize the next downstroke to create a contrast.

Nostal

DESIGNED BY
Maki Shimano

UPPERCASE LETTERS

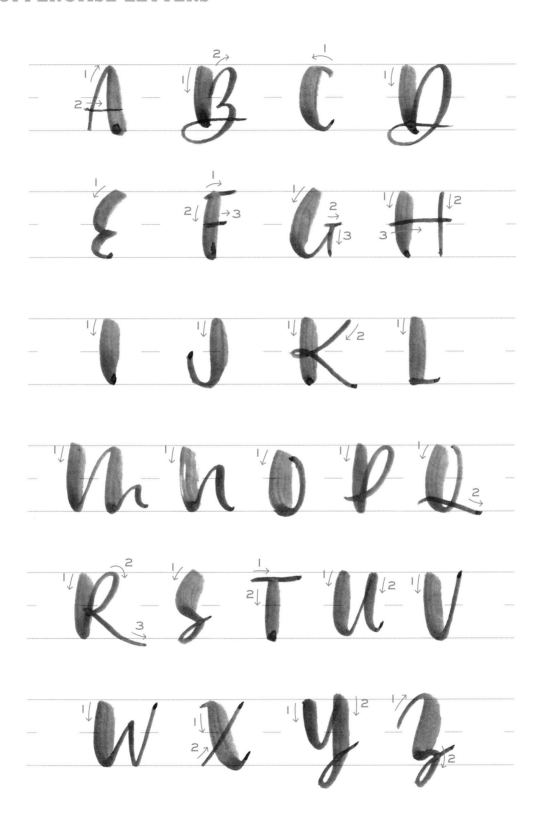

LOWERCASE LETTERS

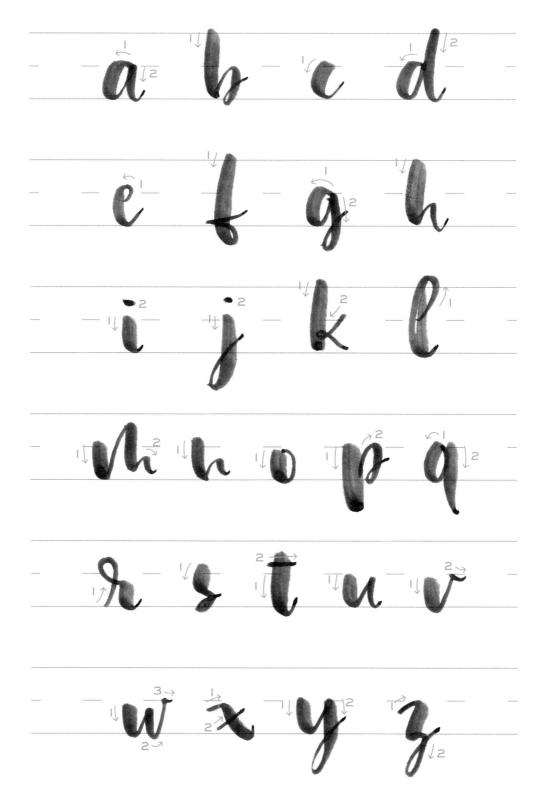

NUMBERS and SYMBOLS

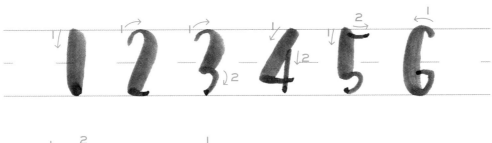

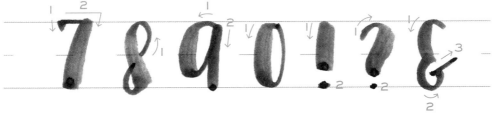

Writing Tips

Taking advantage of the soft brush's characteristics, make the first downstroke with firm pressure. The key is to create significant contrast in the strokes of the letter.

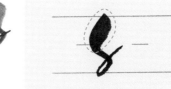

Start by applying pressure evenly on the side of the pen (the flat part) to write boldly, and then gradually release the pressure. Finish by creating a small loop.

For the first stroke, be sure to vary the pressure so that the beginning and end of the line aren't too thick. The second stroke is written from bottom to top.

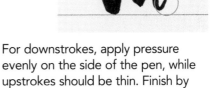

For downstrokes, apply pressure evenly on the side of the pen, while upstrokes should be thin. Finish by releasing the pressure.

Aglaia

DESIGNED BY

Danae

UPPERCASE LETTERS

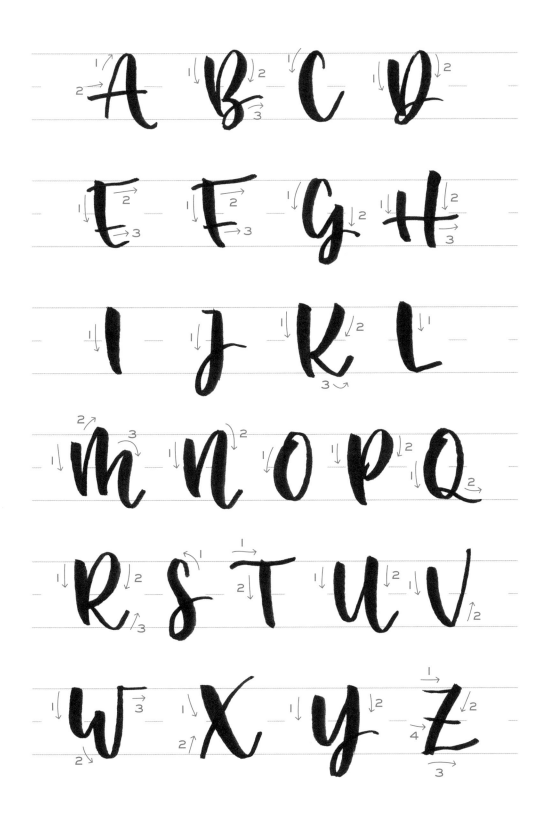

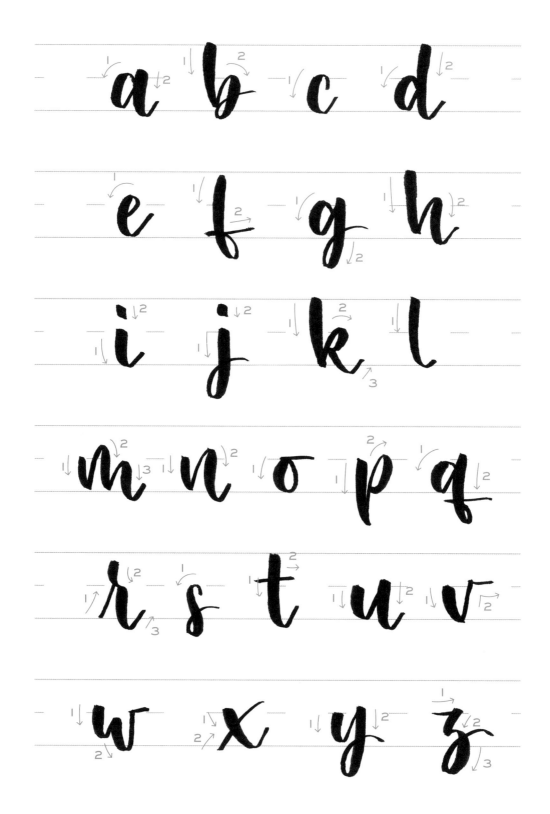

NUMBERS and SYMBOLS

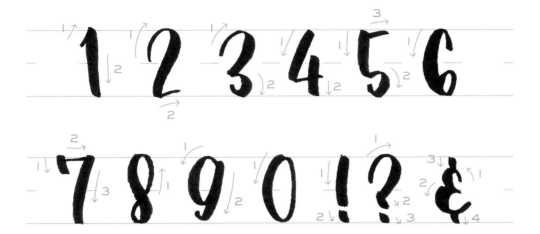

Danae's PORTFOLIO

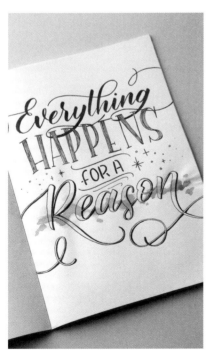

With various colors and font styles, she presents expressions that are both cute and mature, all of which are refined and tasteful. Together with satohom (page 42), she leads "Have Fun Lettering" challenges on Instagram. Her goal is to promote the joy of brush lettering.

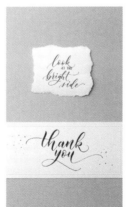

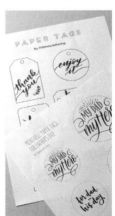

Cute Modern Style

DESIGNED BY

satohom

UPPERCASE LETTERS

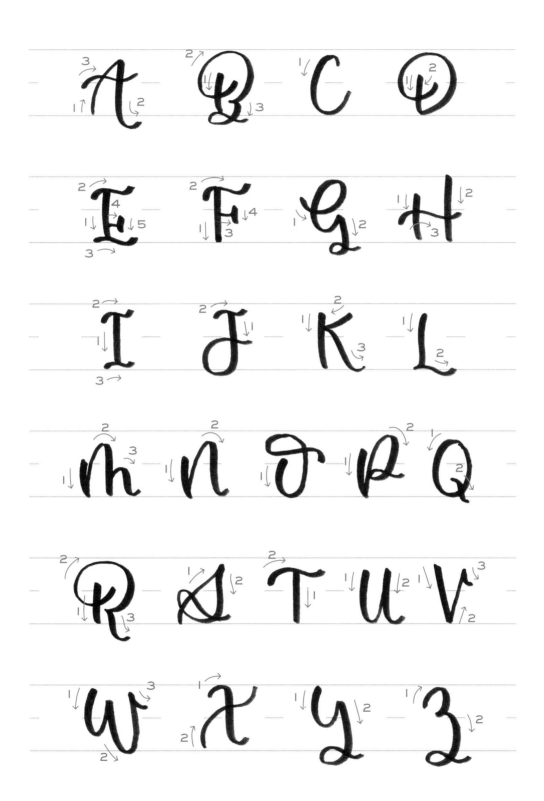

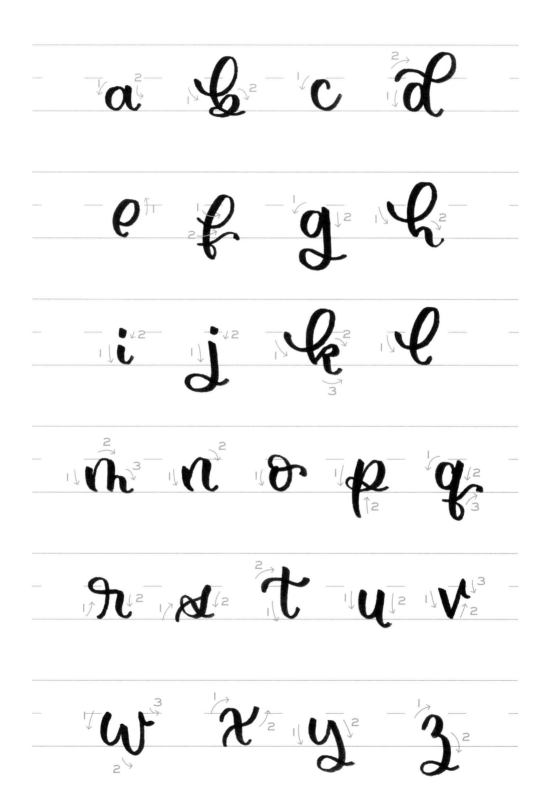

NUMBERS and SYMBOLS

1 2 3 4 5 6

7 8 9 0 ! ? +

satohom's PORTFOLIO

An artist with a vibrant and translucent world of watercolors combined with rounded, feminine letters, creating a unique and lovely impression. Along with Danae (page 38), she leads "Have Fun Lettering" challenges on Instagram, which are open to anyone who wants to participate.

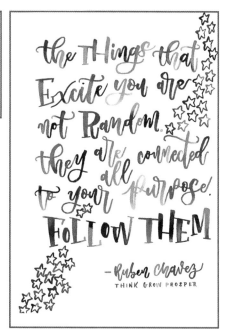

Instagram: @satohom.39

GBS style

DESIGNED BY
RYO KOIZUMI

UPPERCASE LETTERS

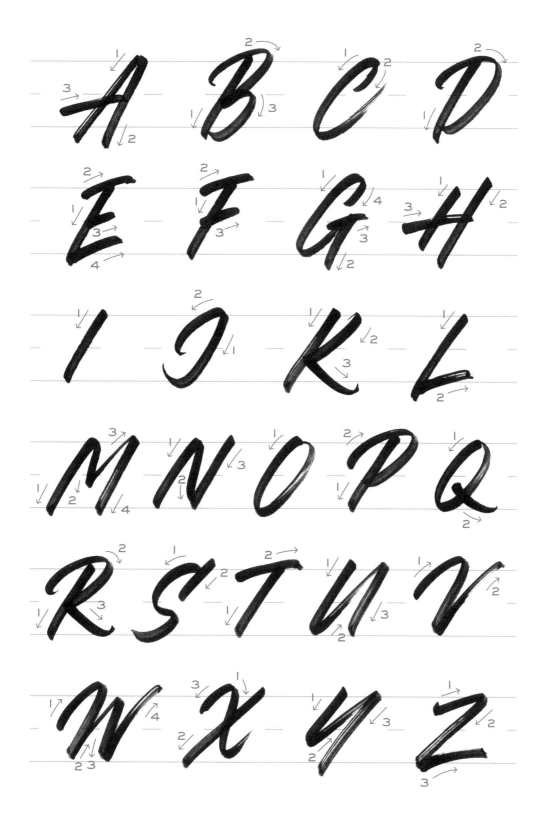

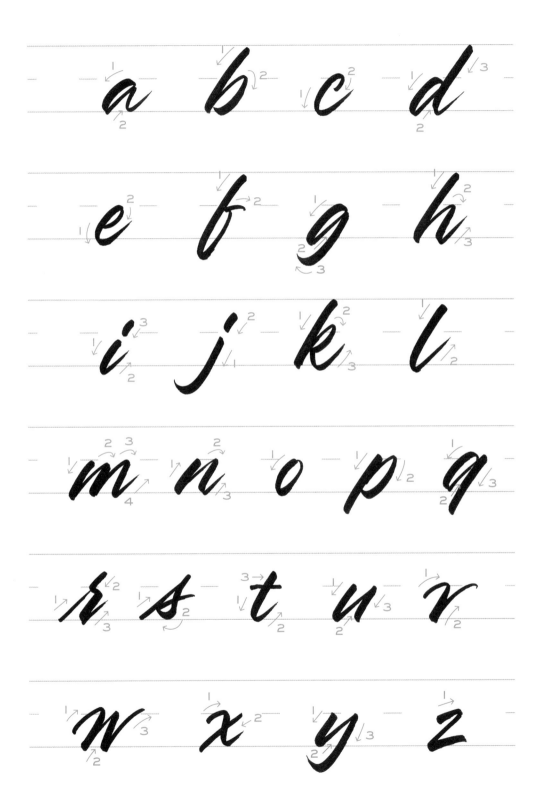

NUMBERS and SYMBOLS

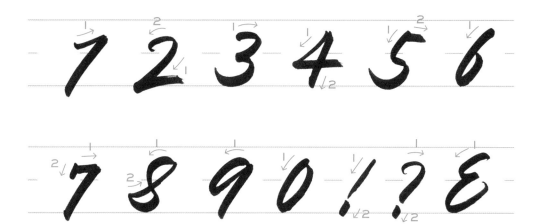

RYO KOIZUMI's PORTFOLIO

A modern calligrapher with sharp lettering and an outstanding dynamic design sense. From the "enso" series drawn by layering each line, to the large murals he draws in offices, his letter designs are widely appreciated by various audiences.

Instagram: @green_and_black_smith

manhattan

DESIGNED BY

oh.soprettyletters

UPPERCASE LETTERS

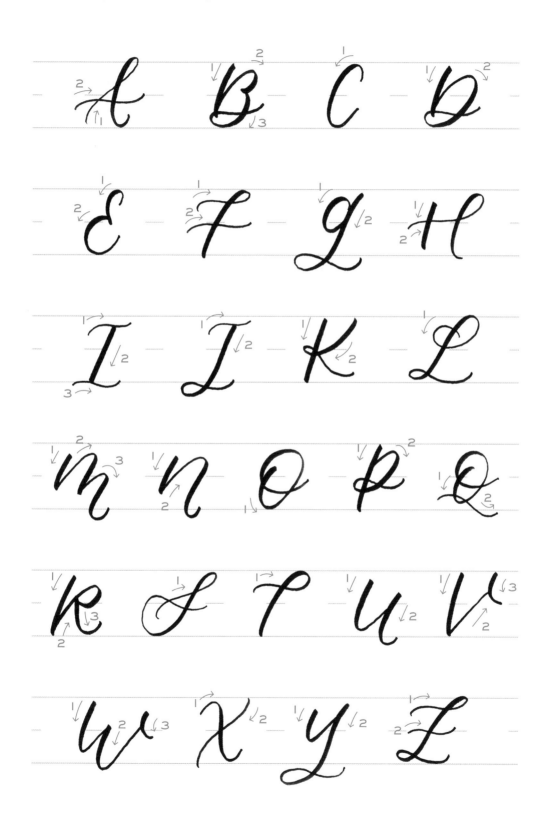

LOWERCASE LETTERS

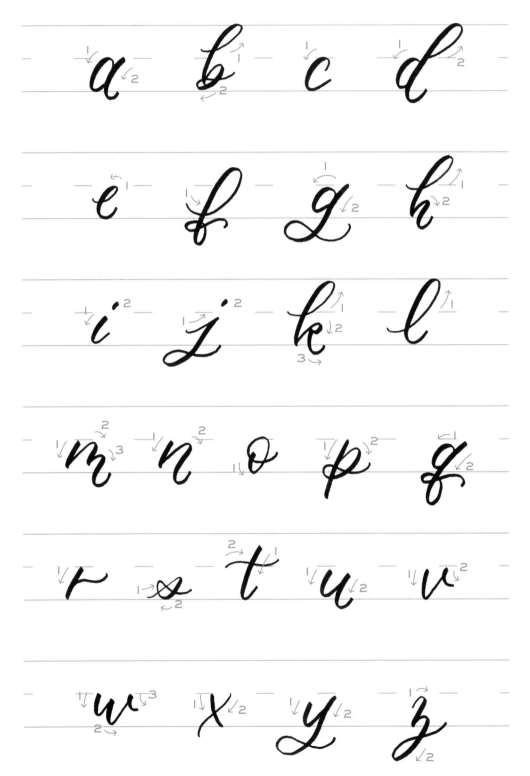

NUMBERS and SYMBOLS

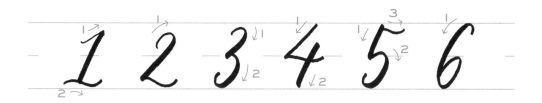

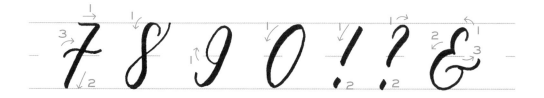

oh.soprettyletters's PORTFOLIO

In Japan, she's one of the few with such a unique cute lettering style. She produces a wide range of artwork, from paper-based to digital. Her pieces, which utilize many flourishes (refer to page 68), are also charming.

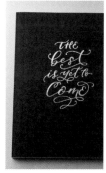

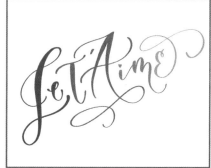

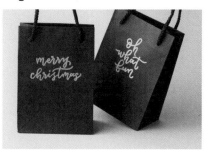

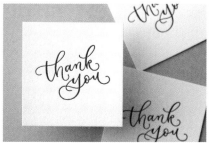

◎ Instagram: @oh.soprettyletters

Let's try it

Samples & Practice Sheet

Enlarge the sample sheets from pages 55–62 to 120%. Overlay them with tracing paper and practice tracing the letters with a brush pen. Once you get used to it, similarly enlarge the practice sheet on page 63 and write while referring to the sample for further improvement.

• Please make copies for personal use only.

Shirahana
Designed by Maki Shimano

A a B b C c D d

E e F f G g H h

I i J j K k L l

M m N n O o P p

Q q R r S s T t

U u V v W w X x

Y y Z z ! ? &

1 2 3 4 5 6 7 8 9 0

Delica
Designed by Maki Shimano

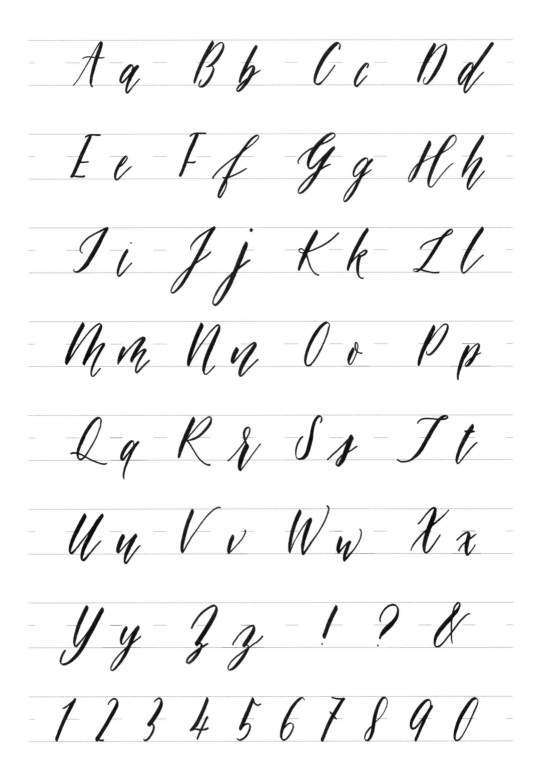

A a B b C c D d

E e F f G g H h

I i J j K k L l

M m N n O o P p

Q q R r S s T t

U u V v W w X x

Y y Z z ! ? &

1 2 3 4 5 6 7 8 9 0

Nostal
Designed by Maki Shimano

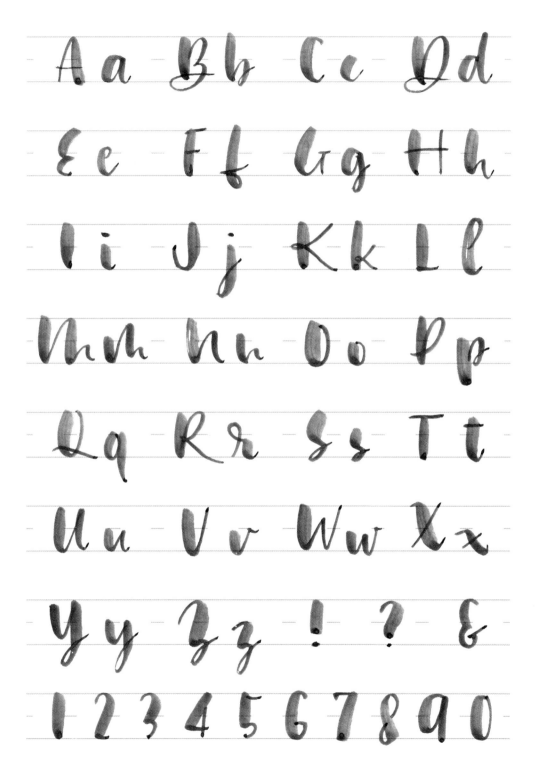

Aa Bb Cc Dd
Ee Ff Gg Hh
Ii Jj Kk Ll
Mm Nn Oo Pp
Qq Rr Ss Tt
Uu Vv Ww Xx
Yy Zz ! ? &
1 2 3 4 5 6 7 8 9 0

Aa Bb Cc Dd
Ee Ff Gg Hh
Ii Jj Kk Ll
Mm Nn Oo Pp
Qq Rr Ss Tt
Uu Vv Ww Xx
Yy Zz ! ? &
1 2 3 4 5 6 7 8 9 0

Aa Bb Cc Dd

Ee Ff Gg Hh

Ii Jj Kk Ll

Mm Nn Oo Pp

Qq Rr Ss Tt

Uu Vv Ww Xx

Yy Zz ! ? +

1 2 3 4 5 6 7 8 9 0

Aa Bb Cc Dd

Ee Ff Gg Hh

Ii Jj Kk Ll

Mm Nn Oo Pp

Qq Rr Ss Tt

Uu Vv Ww Xx

Yy Zz ! ? &

1 2 3 4 5 6 7 8 9 0

Manhattan
Designed by oh.soprettyletters

Aa Bb Cc Dd

Ee Ff Gg Hh

Ii Jj Kk Ll

Mm Nn Oo Pp

Qq Rr Ss Tt

Uu Vv Ww Xx

Yy Zz ! ? &

1 2 3 4 5 6 7 8 9 0

PRACTICE SHEET

Q&A

I've compiled a modern calligraphy Q&A on topics that beginners often wonder about. From questions related to brush pens to the secrets of improvement, you'll find clear answers here.

Q1: How can I make my brush pen last longer?

A1: If you store the pen with the cap facing down, there's a risk of ink leaking from the tip or the ink clogging at the tip. Additionally, consistently writing with the same side of the tip or writing on fabric and textured paper can cause the tip to become misshapen or damaged.

Storage Method

Store with the cap facing up or lay the pen flat to prevent ink from accumulating or leaking. Avoid shaking the pen just because the ink isn't flowing properly. Always make sure the cap is securely fastened.

Making it Last Through Many Writing Sessions

The secret to longevity is to not write using the same side of the tip continuously, but to change the part of the tip being brought to bear throughout your writing sessions.

Tip Maintenance

If the tip becomes dry, soak it in hot water (around 165°F / 75°C), and then gently dab with a tissue to remove excess moisture.

Q2: How should I start practicing?

A2: Start by learning effective brush-pressure control. To do this, I recommend practicing strokes. Practicing strokes is essential to mastering the movement of the pen. If you get bored, change the pen color or try writing words; this way, you can continue to improve while having fun.

Q3: How can I continue to improve?

A3: The key is to write regularly, observe the work of other calligraphers and critique your own work. Don't allow your practice to drop off. Don't be concerned with originality at first. By emulating the work of calligraphers you admire, you'll progress to a point where you'll be able express originality.

Q4: What's the difference between dye ink and pigment ink?

A4: Colorants that are water soluble are called dyes, while those that don't dissolve in water or oil are called pigments. Each has its pros and cons, so choose based on the application.

Dye Ink

✓ Vibrant colors
✓ Easily expresses subtle shades
✓ Suitable for blending and watercolor expression
✗ Poor water resistance and lightfastness
✗ Prone to deterioration with age

Pigment Ink

✓ Doesn't mix even when layered
✓ High water resistance and lightfastness
✓ Quick-drying
✗ Cannot be blended or blurred
✗ Tends to have a higher viscosity and doesn't flow smoothly

Lesson 2

Modern Calligraphy Design

Connecting Letters

Once you've practiced the strokes thoroughly and can write the alphabet, let's practice connecting the letters. Try writing at your own pace.

The easy way to connect letters

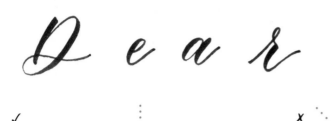

Typically, you'll overlap the next letter with the upstroke to make the connection. Although it's easier to lift the pen off the paper after each letter, if you lift it in the middle of a fine line, the connection will appear unnatural (as shown below).

✓ ✗

Writing by lifting the pen in the middle of letters

The modern calligraphy introduced in this book is a script that connects letters, similar to cursive. However, instead of trying to write an entire word in one pass, view it as a combination of multiple strokes and write each letter carefully.

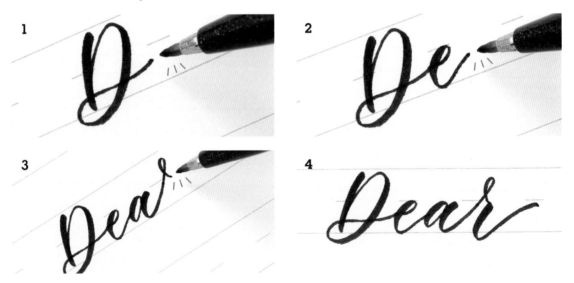

1. Write "D" and lift off.
2. Overlap the end of "D" with the downstroke of "e" to connect them.
3. Overlap the flourish of "e" with the oval of "a," continue writing and lift off after the "r" loop.
4. Connect with a downstroke.

Variations in connections

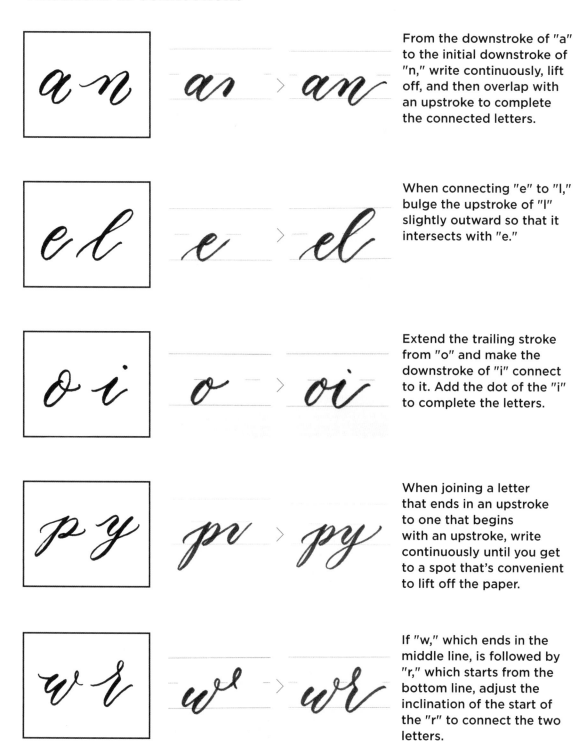

From the downstroke of "a" to the initial downstroke of "n," write continuously, lift off, and then overlap with an upstroke to complete the connected letters.

When connecting "e" to "l," bulge the upstroke of "l" slightly outward so that it intersects with "e."

Extend the trailing stroke from "o" and make the downstroke of "i" connect to it. Add the dot of the "i" to complete the letters.

When joining a letter that ends in an upstroke to one that begins with an upstroke, write continuously until you get to a spot that's convenient to lift off the paper.

If "w," which ends in the middle line, is followed by "r," which starts from the bottom line, adjust the inclination of the start of the "r" to connect the two letters.

How to Add Decorative Flourishes

In modern calligraphy, by adding decorative flourishes, one can express more individuality. It doesn't just make the appearance more lavish—it can also connect letters and adjust the overall balance.

What is a Flourish?

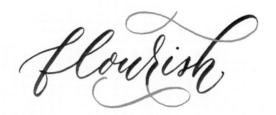

Flourishes are depicted in blue in the photo at left. Extending the end of the line, drawing looping curves or gracefully decorating the letters are all types of flourishes. They are used to embellish the letters with circles, S-shapes, loops, etc., in all directions.

How to Draw Flourishes

It's crucial to consider the overall balance when drawing flourishes. Instead of just designing decoratively, always aim to harmonize the embellishments with the letters.

1. Draw the Base Letters

First, sketch plain letters without flourishes using a pencil. Ensure that you write lightly to leave no trace later on.

2. Add Decorations

Decide on the positions and types of flourishes and sketch the curves with a pencil. Once the overall balance is achieved, move on to the final artwork.

3. Final Artwork

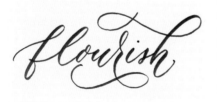

Don't just follow the sketch, but maintain a natural flow when finalizing with ink. Once the ink has dried thoroughly, erase the pencil marks.

Tips for a More Beautiful Appearance

. .

X

Here, the flourishes on the "r" and the "h" are too cramped. Making both loops extend a bit larger and more gracefully results in a better-balanced finish.

X

The "h" is a letter that enables you to extend a stroke upward to the right. Be careful that the flourish doesn't resemble another letter, like an "e," as shown here.

Arrangement Variations

Love

Love

Love

Love

Simple

Simple

Simple

Simple

Adventure

Adventure

Adventure

Adventure

Variations of Flourishes

The letters have been categorized based on the style at the beginning and end of their strokes. If you're unsure about how to apply flourishes, use this as a reference for customization.

Group A
Extends to the Upper Right

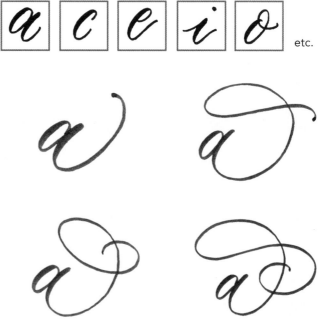

etc.

This group includes many letters and is commonly used at the end of sentences. You can also add flourishes that extend to the top right from the final upstroke in letters like "y" and "g."

Group B
Extends to the Bottom Right

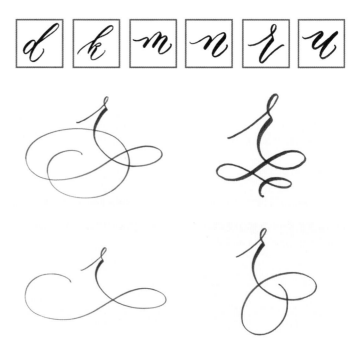

This group can be utilized not just at the end of a sentence, but also as an accent within a sentence. When there's whitespace below the baseline, you can enjoy an elegant design that makes use of this space.

Group C
Extends to the Bottom Left

Flourishes that flow seamlessly can be added to both the beginning and end of a sentence. Adjust the balance of the flourish based on which letters precede and follow it.

Group D
Extends to the Upper Left

This flourish pattern is frequently used as an accent at the beginning or within a sentence. You can connect the decorative part to the letter, either integrating it as you write or adding it at the end.

How to Achieve Balance

One of the most popular writing styles is *bouncy* (writing as if the letters are bouncing). Consider the balance as you raise or lower letters from the baseline, and adjust their sizes.

Adjusting the Balance

Arrange the letters while being cognizant of each one's shape and the overall rhythm. Further adjustment of the intervals between the letters significantly improves readability and aesthetics.

For letters like "o" and "e," which can be expressed smaller, raise them above the baseline to give them a more bouncy effect, creating a height difference with the surrounding letters.

For the final "t," avoid lowering it too much below the baseline. The horizontal stroke of the "t" should be determined while considering the overall balance.

Make the "r," which serves as an accent, slightly larger and more bouncy. It's crucial to convey a natural sense of movement without having the rhythm appearing contrived.

After the bouncy "n," adjust the shape of the following "s" accordingly, ensuring it doesn't appear too droopy on the right.

Express the descender loops of "j" and "y" more prominently. Write smaller letters compactly and finish the writing rhythmically.

Balance the overall design by considering the length of the initial "b" and the final "y" strokes. The descender loop of "y" should be written larger.

Drawing According to Shape

Here are some design examples using frequently used phrases. Designing according to the context of the application is part of the fun. Sketching an outline with a pencil first makes it easier to achieve balance.

Circle

Perfect for writing on round items like coasters and also handy for logos and icons. Sketch with a compass before placing letters or illustrations.

Arrange

After vertically arranging letters and a love letter, draw radial lines from the center for a circular layout.

Once you've drawn a Christmas wreath, place the letters. The wreath illustration is suitable for a circular layout.

Triangle

A triangular design is often used to represent a Christmas tree. By arranging several words in order of letter count, you can create various layouts beyond just Christmas scenes.

Arrange

Write letters around a cherry illustration, and extend the final stroke to achieve balance.

After illustrating glasses, give the letters a sense of volume with expansive flourishes.

Oval

When dividing an oval into upper, middle and lower sections, you can achieve balance by adding flourishes at the beginning and end of words that fall in the middle section or by placing illustrations on the left and right sides of this section.

Arrange

Place smaller words along an arch above the primary word, and use the space below for additional words that take advantage of the white space.

Using all capital letters, tailor the top edges to follow the contour of the top of the oval, forming an arch. For the bottom side, introduce a rounded effect with an illustration.

Diamond

Write words aligned with the central vertical axis of the diamond. You create a cohesive impression by adding a focal point with letters or illustrations at the top and bottom. It's also recommended to draw lines that follow the contour of the diamond shape.

Arrange

When your message spans several lines, writing the main word in the longest line will form a beautiful diamond shape.

In the center, draw a background in the shape of a circle or oval. Write letters that extend at the beginning and end, finishing with a dot.

Wavy Line

A streamlined design where words are written fluidly while varying their shape and size. Writing according to illustrations or wavy lines not only makes it easier to write but also turns the words into accents.

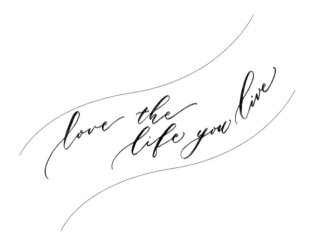

Arrange

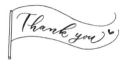

After drawing an illustration of a flag fluttering in the wind, write words along its curve and accompany them with a heart.

When you write along the curve of the moon illustration, the text forms a nice dynamic accent.

Isosceles Triangle

A design of an isosceles triangle can either evoke the image of a ship's sail or be paired with a flag illustration. Mixing fonts and aligning them to the left edge results in a cool finish.

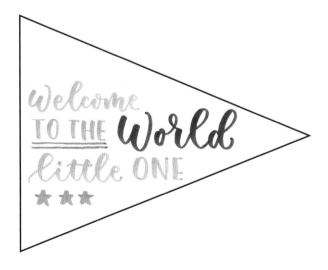

Arrange

WELCOME *make yourself at* HOME!!! 🏠

Place a phrase with many letters in the center and write the words aligned to the left. Finish with an illustration as an accent.

Introduce a bouncy effect into the design. Write the initial letter larger and extend the final letter.

How to Use Colored Brush Pens

Colored brush pens are used not only for writing but also for drawing illustrations or coloring the background behind letters. Adding gradients or blurring broadens the range of expressions.

Types of Colored Brush Pens

Mildliner Brush (Zebra) — Pigment

PITT Artist Pen (Faber-Castell) — Pigment

SHIKIORI Sailor Brush Pen (Yozakura) — Dye

Rushon Magic Petite Brush (Teranishi) — Dye

Dual Brush Pen AB-T (Tombow) — Dye

Art Brush (Pentel) — Dye

Ecoline Brush Pen (Talens) — Dye

Types of Ink

Brush pens come with either dye ink or pigment ink. Dye ink is soluble in water, allowing for blending and blurring. Once pigment ink dries, it no longer dissolves in water. Therefore, one can write with dye ink first, and then color with pigment ink.

Color Combinations

Let's write colorful letters using a wide variety of color brush pens. By changing the color combinations even within the same phrases, you can achieve various styles.

Analogous Colors

Scarlet red, middle purple pink, glazing orange

Combining analogous colors can create a sense of unity throughout. To avoid a monotonous look, it's essential to highlight the differences in colors within the analogous range.

Complementary Colors

Purple violet, green gold, phthalo green

Complementary color combinations can make each color stand out, enabling you to create contrast. Adding a bright color in between makes the text more readable and prevents the colors from clashing.

Chic Colors

Crimson, indanthrene blue, sky blue

A chic color palette featuring muted colors. By keeping the tones consistent, you can mix various colors and still achieve a cohesive look.

Natural Colors

May green, dark chrome yellow, cold gray I

A gentle color scheme that evokes a sense of nature. By using earthy colors like green and brown, you can create a warm and inviting atmosphere.

Cool Colors

Sky blue, ice blue, indanthrene blue

A combination of cool colors like teal, blue and violet evoke a sense of serenity. The gradient of cool colors creates a calm and cohesive impression.

Feminine Colors

Pink madder lake, light indigo, lilac

A traditionally feminine color scheme based on pink. Using a soft pink tone gives it a mature impression that is not cloyingly sweet.

How to Mix Colors

Writing Tool Used: Art Brush (Pentel)
• Note: Pigment inks are not suitable for mixing. Once dry, they don't dissolve in water. Use dye-based inks instead.

Mixing with Pen Tips

You can write with a gradient effect without using a palette, simply by touching the tips of dark- and light-colored pens, respectively. If you want a clear distinction between the shades, combine complementary colors.

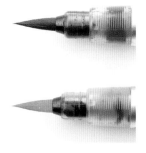
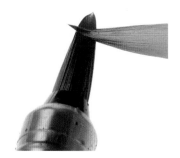
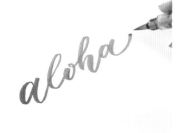

1. Prepare two pens of the colors you want to mix. Here, I've used "Purple" and "Pale Orange."

2. Touch the tip of the dark color (Purple) pen with the light color (Pale Orange) pen to mix.

3. Write with the light-colored pen. Initially, the darker color will appear, gradually transitioning to the original pen color.

Using a Clear Film

Here is a method to mix colors like watercolor paints using a transparent film of plastic as a palette. If you wet the pen tip, you can also write gradient letters with a single pen.

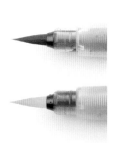

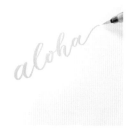

1. Prepare two pens of the colors you want to mix. Here, I've used "Light Green" and "Lemon Yellow."

2. Release the ink of the dark-colored (Light Green) pen onto the film. If the ink doesn't come out easily, squeeze lightly on the cartridge part.

3. Touch the light-colored (Lemon Yellow) pen tip to mix.

4. Write with the light-colored pen. Initially, the darker color will appear, gradually transitioning to the original pen color.

Color Mixing Variations

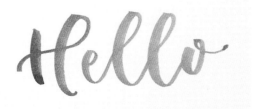

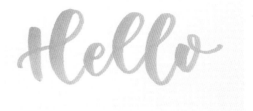

 Blue > 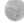 Gray

Writing tool used: *Art Brush (Pentel)*

At the beginning, the Blue appears vividly and gradually transitions to Gray. The clear contrast between the two colors results in a rich and expressive finish.

 Deep Ochre > Light Yellow

Writing tool used: *Ecoline Brush Pen (Talens)*

Combine Deep Ochre and Light Yellow for a gradient with depth. It ends with a clear yellow.

 Turquoise > Lemon Yellow

Writing tool used: *Art Brush (Pentel)*

Combining Turquoise and Lemon Yellow starts with a deep turquoise, gradually transitioning from yellow-green to lemon yellow.

 Red > Pale Orange

Writing tool used: *Art Brush (Pentel)*

Red and Pale Orange combined create a harmonized impression. Mixing colors of the same group with clear shade differences produces a striking effect.

 Magenta > Pastel Red

Writing tool used: *Ecoline Brush Pen (Talens)*

Combining Magenta and Pastel Red produces a gradient of the same color group. It starts with magenta, gradually transitioning to a light pink.

 Olive Green > Gray

Writing tool used: *Art Brush (Pentel)*

A chic gradient transitioning from Olive Green to Gray. It makes a cohesive and calm impression.

Using a Water Brush For Blending

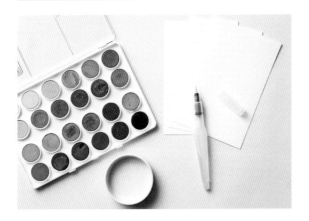

The water brush is used to blur or mix watercolor paints. After drawing an illustration on paper with a brush pen, you can blur it with a water brush. Because the paper will absorb water, it is recommended to use watercolor paper that is less prone to warping or wrinkling.

Materials needed

Water brush / Watercolor paper / Solid watercolor paints / Palette / Container for brush washing

1. Fill the shaft of the water brush with water. Press the shaft, and when the brush tip is wet, pick up some paint.

2. Blend the paint on the palette using the brush.

3. Paint on the watercolor paper. The color will start out intense and then gradually fade.

4. Press the shaft of the water brush to produce drops of water.

5. Blur the areas where the color is intense.

6. Once dry, write with a brush pen.

Mixing Colors

When mixing colors, apply the next color before the previously applied paint dries to blend them together. If the previous paint is dry when the next color is applied, you can layer them without blending.

Tips

Drop water on two colors of paint before they dry and blend them together.

Writing Text

Not only can you create illustrations, but you can also write beautifully graded letters. If the color starts to fade as you write, replenish the paint as needed.

Lesson 3

Design Variations for Commonly Used Phrases

New Year's Day

Designed by Danae

In addition to the main text color, add colorful shadows. Further enhance it with sparkles to convey the festive atmosphere of the New Year.

Designed by RYO KOIZUMI

Designed by satohom

Create a colorful background with a watercolor look, and then write the phrase on top. Just changing the background color can completely alter the overall feeling of the composition.

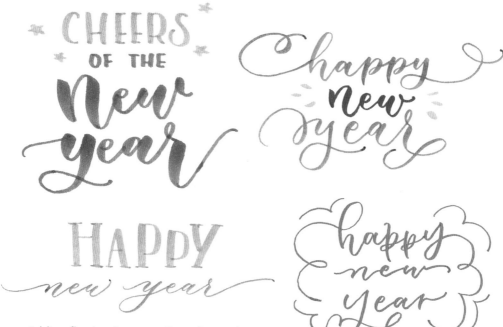

Adding flowing "new year" text beneath the dynamic "HAPPY" letters, with varying heights, will enhance the contrast and add a sense of movement.

Designed by oh.soprettyletters

This is the design that is featured in the card-making tutorial on page 125. Utilizing masking techniques effectively can result in a three-dimensional finish.

LOVE

FOR

you

WITH

MY

whole heart

you are my love

I ❤ you

Draw a letter motif in the center and arrange the words to fit around it. Drawing a circle in pencil first helps you to write in a balanced manner.

love you

ALL YOU
need is
Love

Love

Love

Happy
Valentine's
Day

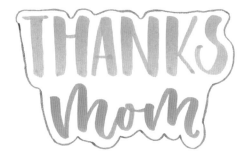

Sketch a heart shape with a pencil and write a message along it. If connecting the words is challenging, sketch the letters too.

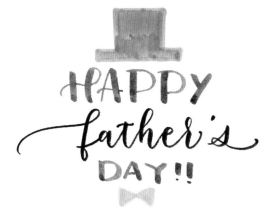

Design the words for Father's Day with an image of a hat and bow tie. Adding a simple illustration makes the design much cuter.

Halloween

Designed by RYO KOIZUMI

Designed by satohom

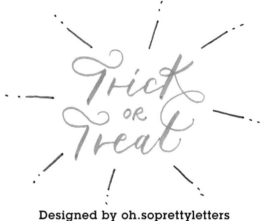

Designed by oh.soprettyletters

Create a casual and elegant Halloween expression using thin lines. The letters are designed to be reminiscent of tangled spider webs.

Gradually decreasing letter sizes in a similar color gradient (refer to page 78). Add a black border and spider web to make it more Halloween-like.

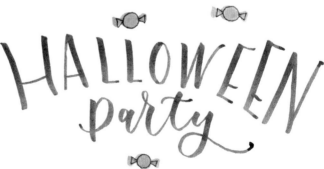

BOO!

HAPPY halloween

If you use a color brush pen (like the Ecoline Brush Pen) that can produce variations in saturation with a single stroke, you can draw a three-dimensional watercolor-like pumpkin.

TRICK OR TREAT

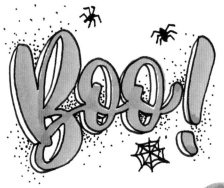

Trick
OR
Treat

Roughly draw a ghost with a light-colored brush pen, and then surround it with a slightly offset outline using a sign pen. Use sharp lettering inside the speech bubble for emphasis.

Boo!

Designed by Danae

halloween

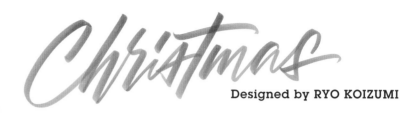

Designed by RYO KOIZUMI

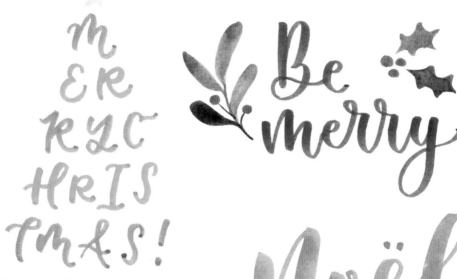

Designed by oh.soprettyletters

Using only uppercase letters gives a casual, contemporary impression. By being creative with colors, you can evoke a seasonal feel even if you're not a strong artist.

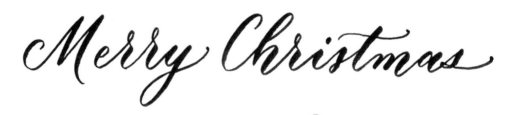

Designed by Danae

Mix inks using blue and red brush pens (refer to page 78). Writing this way naturally creates a gradient, resulting in a beautiful finish.

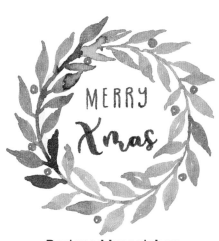

Designed by satohom

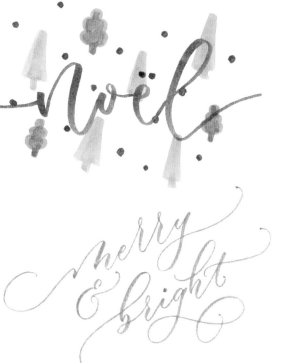

Design a Christmas ornament silhouette through letter placement. Careful planning from the start is the key to achieving a balanced finish.

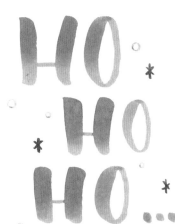

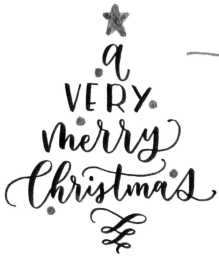

Form a common holiday phrase into the shape of a Christmas tree. If there's too much empty space, it's good to add ornament-like dots in Christmassy colors.

Birthday

happy birthday

Designed by RYO KOIZUMI

HAPPY
Birthday

Designed by satohom

Design with flowers or leaves matching the recipient's favorite colors or the season. Changing the color of flowers or leaves can completely transform the look of the composition.

Birthday

Designed by oh.soprettyletters

Sprinkle simple shapes like □, △, ○, ☆ in your favorite colors, and then overlay the text. This lends a contemporary feel to the birthday message.

HAPPY
birthday
TO YOU!!

IT IS
your
DAY!!

Balloons are an indispensable
motif for birthday messages.
Superimposed letters creates a cute
design suitable for birthday cards.

HAPPY HAPPY HAPPY
Birthday
TO YOU

Designed by Danae

Using three kinds of green brush pens,
arrange the initials of "Happy Birth Day."
Write the center letter slightly larger, and
encircle them with gray.

Happy
birthday
to you

happy BIRTHDAY

happily ever after

Best Day Ever

Design the classic wedding phrase in three lines and unify it in shades of pink. Adding a light gray shadow gives it a three-dimensional look.

happily ever after

Save the Date

Using a soft brush pen, draw leaves to create a frame (refer to page 123) and add a message in rustic, rough lettering.

Groom Bride

Wedding Reception

When expressing text in two lines, be mindful of overlapping letters and spacing. Ensure that the slanting is consistent, and give it a slight bounce.

love you to the Moon & Back

Designed by satohom

happy wedding

Designed by satohom

Imagine a cake decorated with a cake topper. Simply changing the text inside the cake topper makes this motif adaptable to various situations.

groom

bride

Happily ever after

Designed by Danae

JUST
Married!!

we're so glad you're here!

take your seat

Designed by oh.soprettyletters

Designs suitable for small gift tags to large welcome sign boards. Adjust the balance with flourishes to avoid too much white space.

Words commonly accompanying place cards set at guest seats during weddings. It's designed to be simple and readable.

Wedding

Designed by RYO KOIZUMI

Save THE *Date*

This design is presented in the card-making method on page 129. Pairing a different style of lettering for "THE" tightens the overall look.

we ♥ do

Mr & Mrs

table

Save our Date

Designed by oh.soprettyletters

TABLE *no.*

By pairing numerals with the design above, you can use it as a table number designation card. The design is rather structured, ensuring that any style of written numbers will look good with it.

Mr & Mrs

Designed by Danae

Wedding

Designed by RYO KOIZUMI

Designed by satohom

This banner motif is perfect for heralding a baby's arrival. Ribbons and banners are easily adaptable, so try various arrangements according to the message.

Designs distinguished for a newborn baby boy and girl. Placing text on balloon illustrations is an adorable finishing touch (refer to pages 90–91).

Designed by RYO KOIZUMI

OH
LOVELY
baby ♡

Designed by Danae

After writing the main "baby," add "OH LOVELY" text and illustrations while considering the overall balance. Make good use of the white space.

Dad 〜

Mom

OH!!!

baby

Hello baby!

Designed by oh.soprettyletters

Oh
BABY!

CAN'T WAIT
the
little ONE!

A standard message suitable for a baby shower before the baby is born. This is a design that emphasizes "ONE" for contrast.

Hello
world

Diary

Thank You

Write the block letters "THANK" with a light-colored brush pen and overlay "you" with a darker brush pen, considering left-to-right balance.

Design flourishes so that the words "Thank You" fit perfectly inside a circle. It's recommended to sketch with a pencil first.

Welcome

Welcome

WELCOME

A design incorporating the popular bubble effect in the lettering. After writing the text, express the highlight of the three-dimensional bulge with a very fine white sign pen.

Welcome

Welcome

welcome

Overlay delicate letters onto simply drawn botanical illustrations with a fine sign pen. This design exudes a natural vibe.

WELCOME make yourself at HOME !!! 🏠

Welcome

Congratulation

Designed by satohom

Congrats

Designed by Danae

To easily create white-filled text, write letters with a thick brush pen, overlay another paper, and finish by tracing the silhouette with a fine sign pen.

Congratulations

Congrats!

Congrats!!

Designed by oh.soprettyletters

A versatile design with a message inside a speech bubble. Various arrangements can be produced depending on the bubble shape and text slant.

Congratulations!!

Congrats!

After sketching with a compass, write the text to fit inside the circle with a thick brush pen. Overlay with a sign pen for emphasis.

Quickly paint a region diagonally with a light-colored, thick brush pen. Overlay the text with flourishes for a casual look.

Designed by RYO KOIZUMI

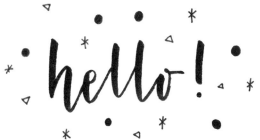

Designed by oh.soprettyletters

A handy design usable in various situations such as notebook headings. Adding details like outlines or shadows to simple words makes them stand out.

First, roughly draw a circle. Then, illustrate the flowers, etc. with a 0.1-mm fine-tip pen. Pair with rounded and dynamic letters for a cohesive look.

Designed by RYO KOIZUMI

hello!

HELLO

Designed by satohom

Achieve a delicate balance by varying heights and sizes of each letter and mixing uppercase and lowercase.

Hello

HELLO
everyone

Designed by Danae

Draw a speech bubble with a light-colored thick brush pen, and then overlay with a slightly offset fine sign pen. Keep the text simple.

12 Months

January February

March April

May June

July August

September October

November December

Jan. Feb. Mar. Apr.

May Jun. Jul. Aug.

Sep. Oct. Nov. Dec.

Spring

Summer

Autumn

Winter

SPRING *spring*

Summer

Autumn

Winter

Sunday Monday

Tuesday Wednesday

Thursday Friday

Saturday

Sun. Mon. Tue. Wed.

Thu. Fri. Sat.

Designed by satohom

After drawing an illustration of the present, write the letters inside. Combining various letter designs creates a festive look.

Designed by Danae

Adding bold vertical strokes makes for a dynamic presentation. For a softer look, the two "menu" designs on page 109 are also recommended.

Menu

Dear

Step
BY
Step

Check it

Designed by RYO KOIZUMI

TODAY'S
special

menu

Especially for you

CHEERS!

cheers

Designed by oh.soprettyletters

Being careful to preserve readability, mix upper and lowercase letters. Deliberately leave letters unconnected, and use flourishes to bring the whole composition together glamorously.

Feeling

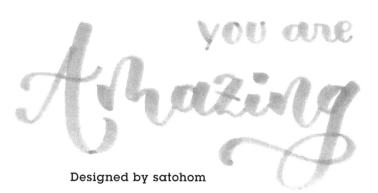
you are Amazing

Designed by satohom

Awesome!

Designed by RYO KOIZUMI

Write the "A" and the final "e" with long, outward-projecting strokes, and balance the whole word with an underscore. When writing swiftly, you can produce strokes with stylish white streaks.

Go for it!

Love

Designed by oh.soprettyletters

Cute

thinking…

A design inspired by the word that comes to mind. It can be used in various ways, such as to decorate planners and notebooks. Pair it with simple letters with minimal bounce.

Designed by Danae

Under the illustration, write the expansive word "good," and for the word "night" below it, transition the tilt of the letters from left to right.

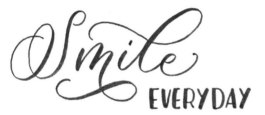

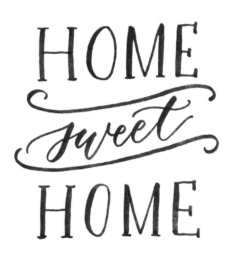

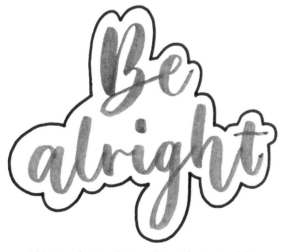

This is a design that outlines the text while leaving a nice margin around the letters. When you want to emphasize the letters written in a planner or notebook, this is an easy method to use.

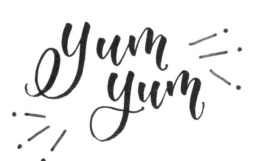

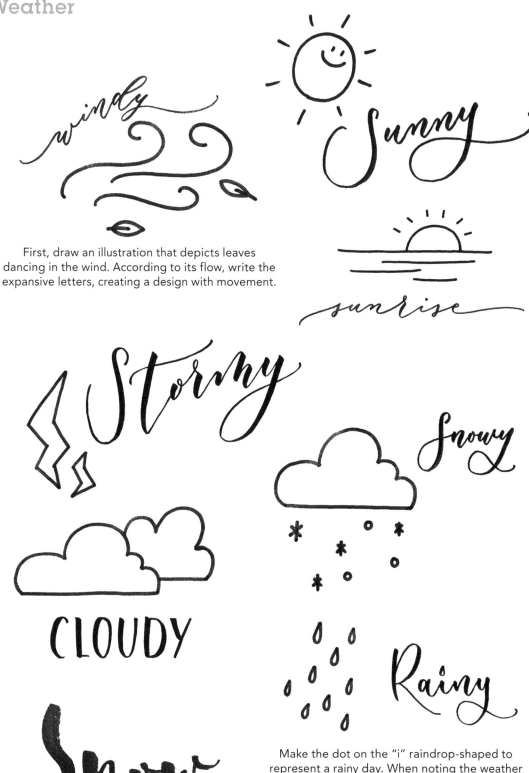

First, draw an illustration that depicts leaves dancing in the wind. According to its flow, write the expansive letters, creating a design with movement.

Make the dot on the "i" raindrop-shaped to represent a rainy day. When noting the weather in journals, adding a simple illustration makes it instantly clear what the day's weather was like.

Lesson 4

Modern Calligraphy in Daily Life

Appointment Books

Because a planner is something you have with you all year round, I introduce modern calligraphy techniques for planners that make you feel excited every time you open it to look ahead, or energize you when you look back. Don't miss out on ideas to make it look more glamorous.

At least one word per day is my rule. On days with no plans, writing down the weather or mood makes for a pleasant feeling of nostalgia when looking back. Summarize in a nuanced colors and accentuate with washi tape.

MARCH

Friday	Saturday	Sunday	Notes
Vol.1		DAY 1 *workshop"* POP ✿1 UP	week 9
workshop BEGINNER 6	LAST! *Obento* 7	*cloudy* ✿8	week 10
workshop INTERMEDIATE 13	*Rehearsal* 14	CONGRATS *ceremony* ✿15	week 11
workshop ADVANCED ✿20	*workshop* BEGINNER ✿21	*workshop* FOR GIFT! 22	week 12
Project * TOKYO *	*Sawa birthday*	LUNCH *cicada*	week 13
V 27 A C A T I O N	28 S P R I N G V	29 A C A	week

Bullet Journals

22 *Sun.*

23 *mon.*

24 *Tue.*

25 *Wed.*

26 *Thu.*

27 *Fri.*

28 *Sat.*

S	M	T	W	T	F	S	
	1	2	3	4	5	6	7
8	9	10	11	12	13	14	
15	16	17	18	19	20	21	
22	23	24	25	26	27	28	
29	30	31					

→→ 119 ←←

Write your goals for the week on the left page and the schedule on the right. If it's a dot-grid planner, the markings can serve as a guide when writing letters or lines. Organize with cool colors for a calming presentation.

Scrapbooks

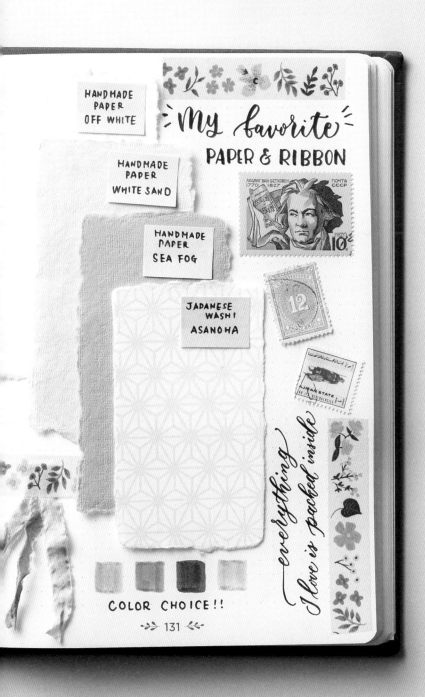

My *favorite* PAPER & RIBBON

HANDMADE PAPER OFF WHITE

HANDMADE PAPER WHITE SAND

HANDMADE PAPER SEA FOG

JAPANESE WASHI ASANOHA

everything I love is packed inside

COLOR CHOICE!!

→→ 131 ←←

First, roughly decide on a format. Before writing, glue larger items such as envelopes to serve as a substitute for pockets. Coordinating the design with seasonal colors lends a sense of unity.

Travel Journals

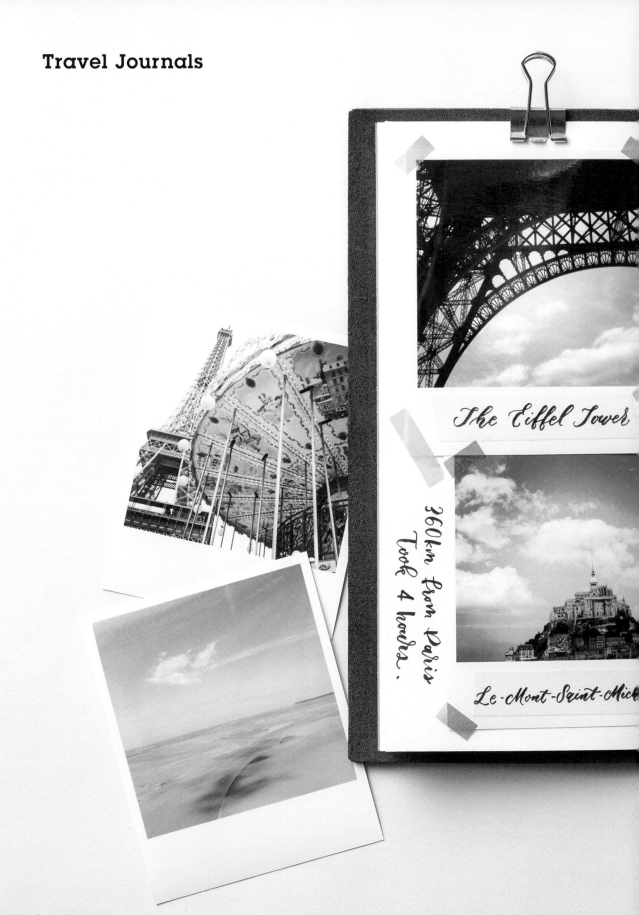

The Eiffel Tower

360km from Paris Took 4 hours.

Le-Mont-Saint-Mich

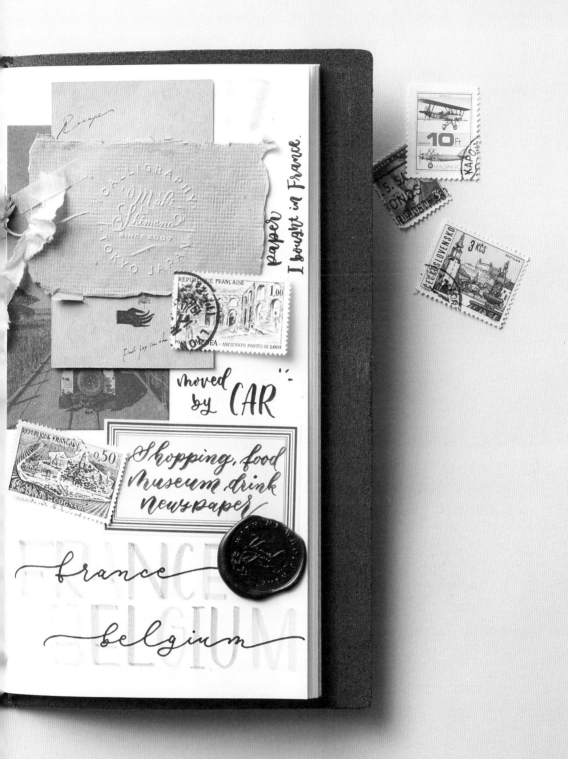

On the left page, glue memorable photos from places you've visited, and on the right, collage items like stamps or clothing tags. Adding words with a black pen at the end gives it a cohesive look.

Here, I show you how to design a card decorated with thoughts or messages for someone special using modern calligraphy. By adding illustrations or watercolor patterns, it becomes more charming and likely to be displayed and cherished.

Christmas Cards

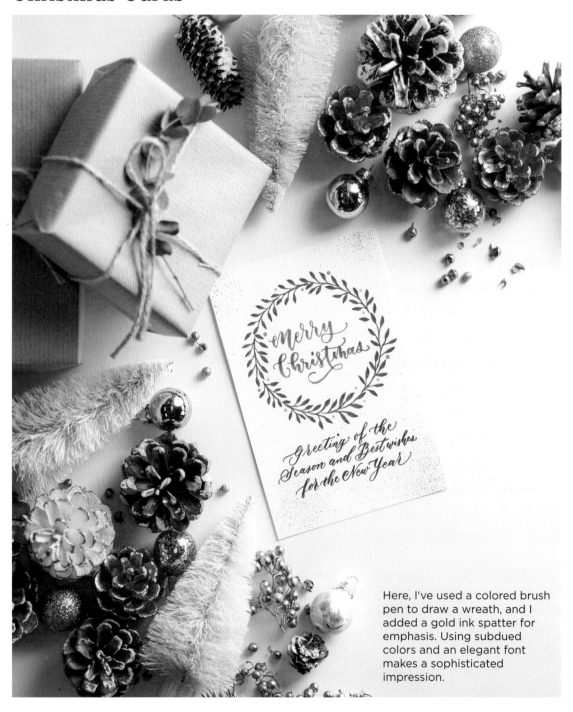

Here, I've used a colored brush pen to draw a wreath, and I added a gold ink spatter for emphasis. Using subdued colors and an elegant font makes a sophisticated impression.

Writing Tools Used

Art Brush: Olive Green, Turquoise (Pentel) / PITT Artist Pen: Gold, Silver (Faber-Castell) / Golden Brush (Pentel) / Fude Touch Brush Sign Pen: Black (Pentel)

1. On a postcard-size piece of paper, draw a circle with a diameter of 2¾ in (7 cm) using a compass.

2. Draw stems along the sketched circle using a brush pen, drawing from bottom to top without applying much pressure.

3. Draw half of a leaf at the end of the stem. Gradually apply pressure, and then release the pressure and finish the stroke.

4. Draw the other half of the leaf in the same way.

5. Repeat steps 3–4, drawing a leaf at the end of each stem.

6. Repeat steps 2–5, continuing to draw stems and leaves around the circle.

 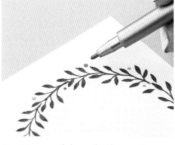 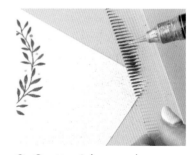

7. Once you've drawn around the entire circle, add more stems and leaves where needed to balance out the design.

8. Use gold and silver sign pens to add dot patterns between the leaves.

9. Spatter ink onto the paper using a comb or fine mesh. Once dry, erase the pencil sketch lines and write your message to complete the card.

New Year's Greetings

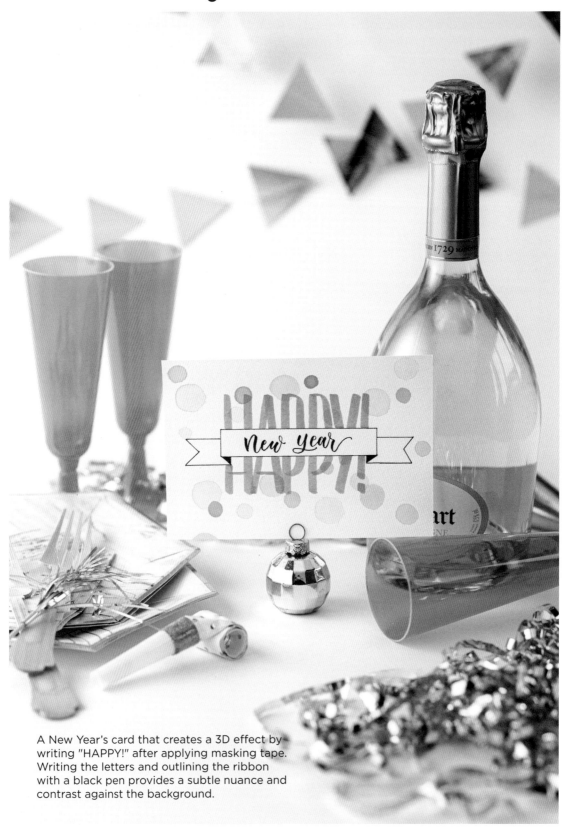

A New Year's card that creates a 3D effect by writing "HAPPY!" after applying masking tape. Writing the letters and outlining the ribbon with a black pen provides a subtle nuance and contrast against the background.

Writing Tools Used

AB-T: 803 Pink Punch (Tombow) / Art Brush: Pale Orange, Lemon Yellow (Pentel) / Fude Touch Brush Sign Pen: Black (Pentel)

1. On postcard-size watercolor paper, sketch a center line and a ½ in (1.5 cm) wide ribbon.

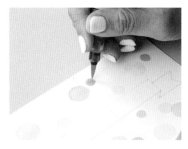

2. Draw and fill in circles using a brush pen.

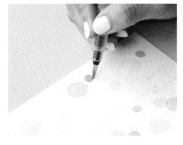

3. Before the ink dries, blur the outlines with a water brush (refer to page 80). Repeat steps 2–3, adding a pattern of dots while balancing the design.

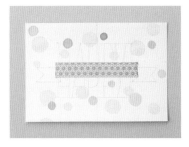

4. Sketch the word "HAPPY!" and tape over the ribbon sketch using ½ in (1.5 cm) wide masking tape.

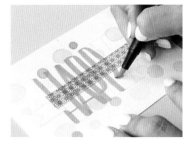

5. Trace the sketched word with a brush pen over the masking tape.

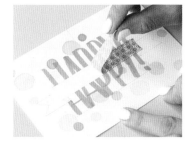

6. Once dry, carefully remove the masking tape.

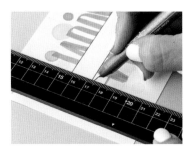

7. Using a ruler, trace the ribbon sketch with a fine-tip pen.

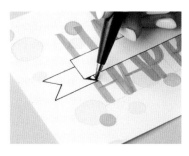

8. Fill in the overlapping parts of the ribbon with a black brush pen.

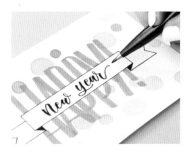

9. Write on the ribbon using a brush pen, let it dry, and then erase the pencil sketch lines to complete the card.

Birthday Cards

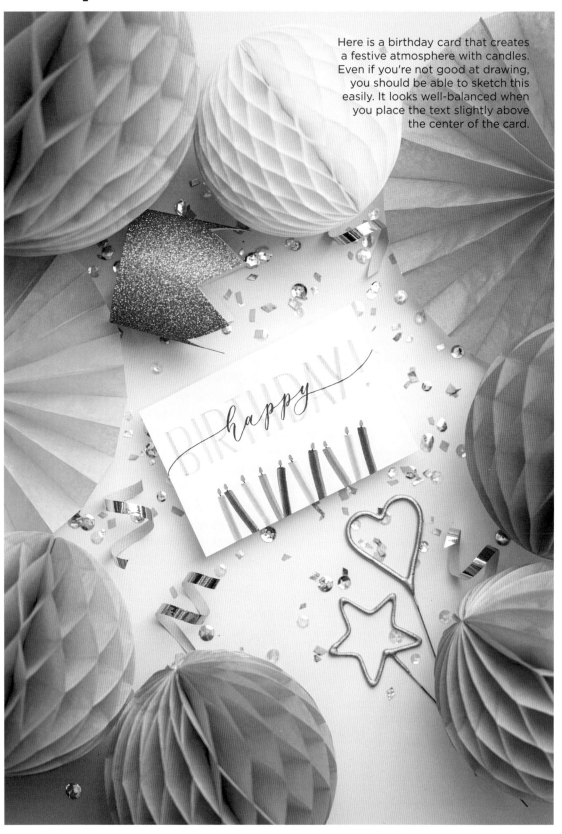

Here is a birthday card that creates a festive atmosphere with candles. Even if you're not good at drawing, you should be able to sketch this easily. It looks well-balanced when you place the text slightly above the center of the card.

Writing Tools Used

AB-T: 452 Process Blue, 528 Navy Blue, 803 Pink Punch, N75 Cool Grey 3 (Tombow) /
PITT Artist Pen: Gold (Faber-Castell) / Fudenosuke Firm Tip: Ink Black (Tombow)

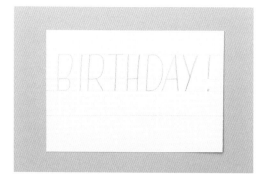

1. On a postcard-size paper, sketch guidelines and the word "BIRTHDAY!" with a pencil.

2. Trace over the sketched text with a brush pen. Apply light pressure for horizontal lines and press harder for vertical and diagonal lines.

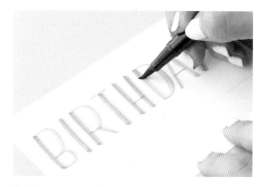

3. Trace over the vertical and diagonal lines to produce a three-dimensional effect.

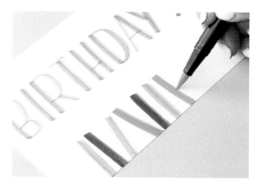

4. Draw randomly spaced and angled candles with a brush pen according to the guidelines. Fill with color in the same manner as in step 3.

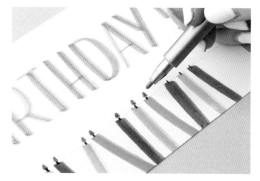

5. Draw the wick and flame of each candle with a fine-tip pen.

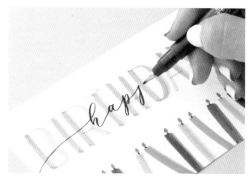

6. Once dry, erase the pencil guidelines and sketch marks, and then write the word "happy" with a brush pen to complete the card.

Save-the-Date Cards

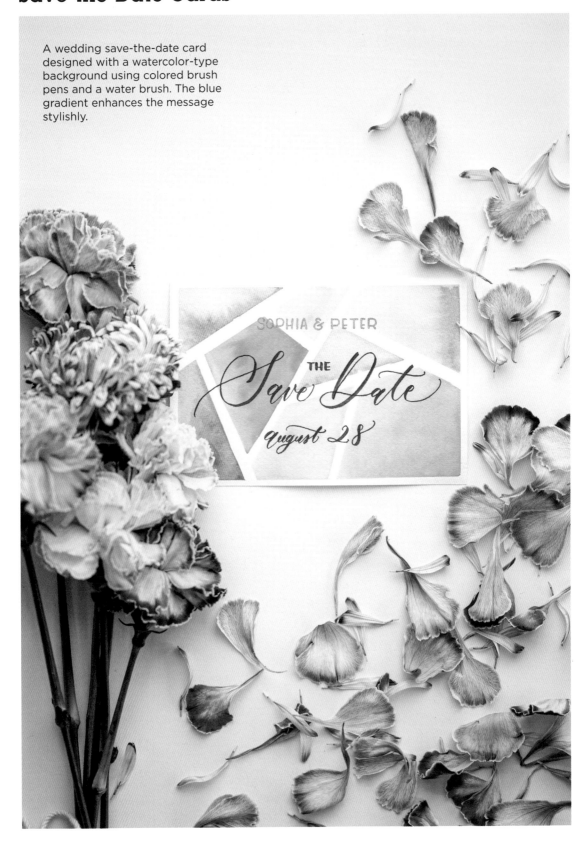

A wedding save-the-date card designed with a watercolor-type background using colored brush pens and a water brush. The blue gradient enhances the message stylishly.

Writing Tools Used

Art Brush: Steel Blue, Turquoise, Sky Blue, Gray (Pentel) / PITT Artist Pen: Gold (Faber-Castell) / Fude Touch Brush Sign Pen: Black (Pentel)

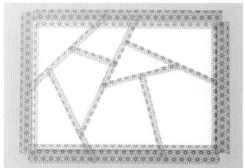

1. Tape around a postcard-size watercolor paper and randomly position thinly cut masking tape.

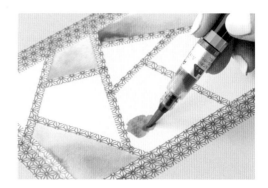

2. Fill the frames with color using a brush pen.

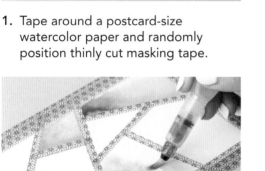

3. Blend with a water brush before the ink dries (refer to page 80).

4. Repeat steps 2–3. Once dry, carefully remove the masking tape.

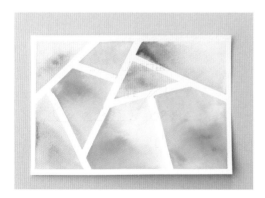

5. Sketch the text lightly with a pencil. Drawing guidelines helps to balance the text's spacing and width.

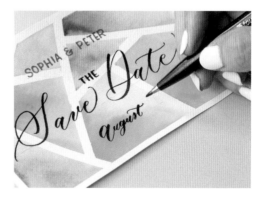

6. Trace the sketch with a brush pen, let it dry, and then erase the pencil marks to finish. If the paper wrinkles, place a cloth over it and iron the wrinkles out.

Birth Announcements

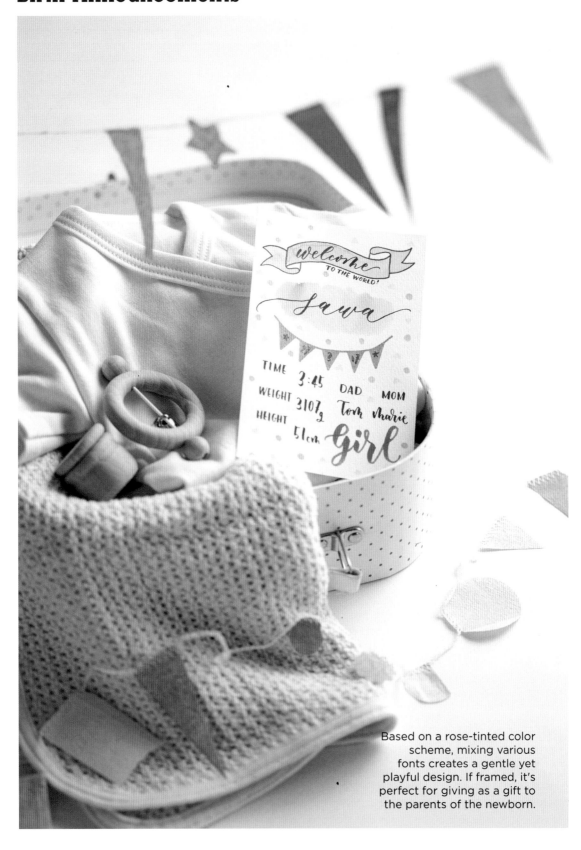

Based on a rose-tinted color scheme, mixing various fonts creates a gentle yet playful design. If framed, it's perfect for giving as a gift to the parents of the newborn.

Writing Tools Used

Art Brush: Pale Orange, Pink (Pentel) / PITT Artist Pen: Gold, Glazing Light Yellow, Medium Skin (Faber-Castell) / Ecoline Brush Pen: Magenta (Talens) / Fude Touch Brush Sign Pen: Black (Pentel)

1. Sketch on a postcard-size watercolor paper. Draw everything lightly except for the banner and pennant string.

2. Color in the banner with a brush pen.

3. Blend the color with a water brush before the ink dries (refer to page 80).

4. Color between the banner and the pennant string in the same manner as in steps 2–3.

5. Draw the pennant string with a gold sign pen and surround it with filled circles and triangles using colored brush pens.

6. Trace the banner's sketch lines with a fine-tip pen.

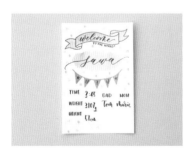

7. Write the text with a black brush pen.

8. Write the word "girl" with a color brush pen.

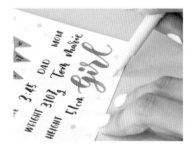

9. Adjust the balance and add filled circles or triangles where it feels empty, let it dry, and then erase the pencil sketch marks to complete.

Phrases for Gifts

Congrats on entering School

Mr. &
24 Gree
L
N
Unit

Dearest Ayané

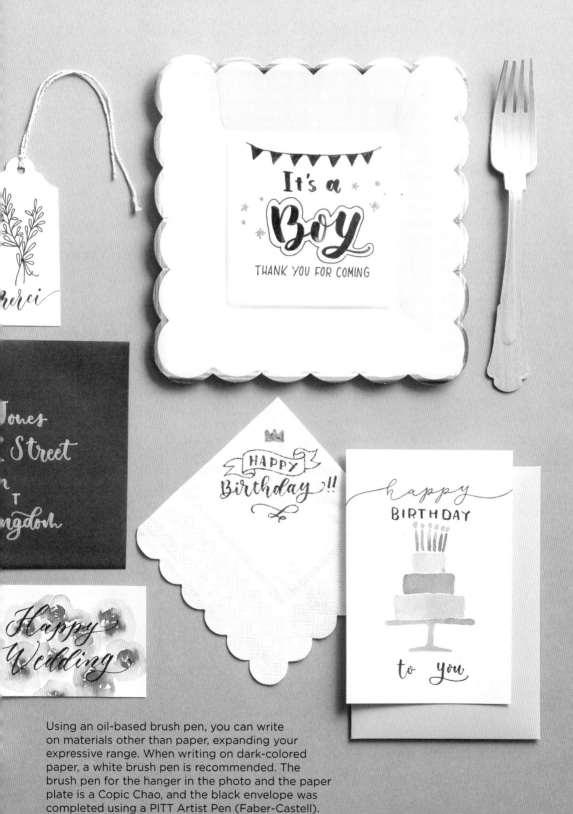

Using an oil-based brush pen, you can write on materials other than paper, expanding your expressive range. When writing on dark-colored paper, a white brush pen is recommended. The brush pen for the hanger in the photo and the paper plate is a Copic Chao, and the black envelope was completed using a PITT Artist Pen (Faber-Castell).

Wrapping a present in a way that honors the recipient is a wonderful way to make the gift more memorable. By adding modern calligraphy to the equation, your gift will be that much more thoughtful.

Wrapping Paper

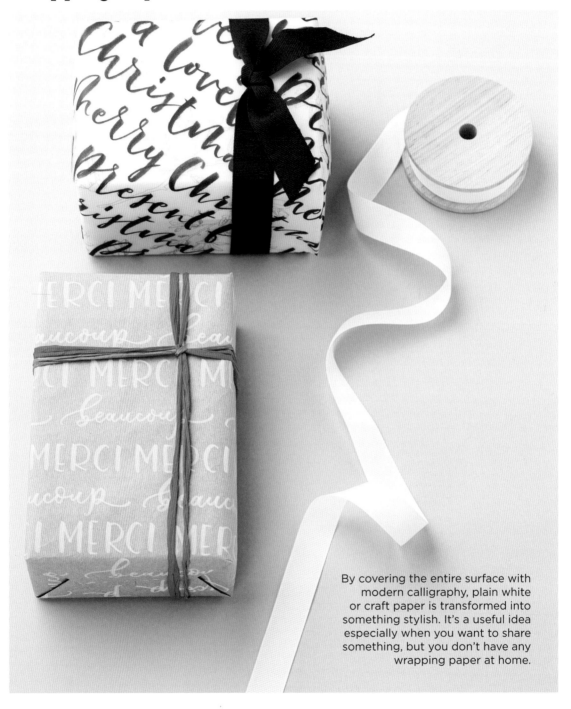

By covering the entire surface with modern calligraphy, plain white or craft paper is transformed into something stylish. It's a useful idea especially when you want to share something, but you don't have any wrapping paper at home.

Draw 45-degree guidelines with a pencil, and then write the letters. Even if it's not exactly as you've sketched, be conscious of writing rhythmically. Using paper with faint line drawings printed on it makes the end result more elegant.

Writing tool used:

PITT Artist Pen: White (Faber-Castell)

Writing tool used:

Art Brush: Black (Pentel)

First, lightly sketch out the guidelines with a pencil. Then, alternate between modern calligraphy and block letters as you write. By using a white brush pen on craft paper, you create a natural look.

Ribbon

Decorate the ribbon using a brush pen that can write on fabric. Make sure to write on it when it's taut, perhaps by using masking tape to stretch and hold it. Ironing it as a finishing touch will make the ink less likely to fade when washed.

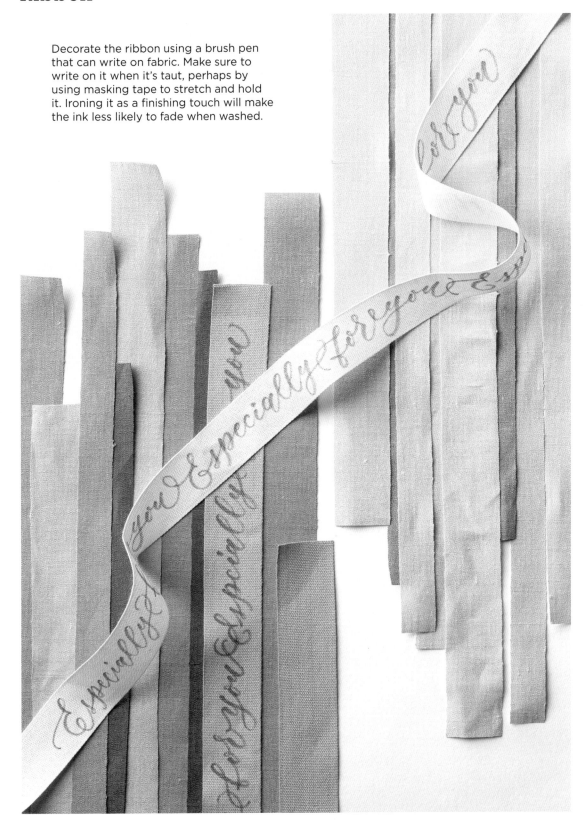

Writing tool used:

ZIG Fabricolor Twin: Green Gray (Kuretake)

1. Select a brush pen that can write on fabric. The pen pictured at the top in the photo above is specifically for fabric. Below it is the PITT Artist Pen (Faber-Castell), a brush pen with pigment ink that becomes water-resistant when dry.

2. Space out the ribbon at intervals of 11¾–15¾ in (30–40 cm) and temporarily secure it using masking tape to ensure it's stretched taut.

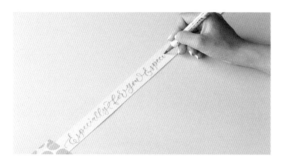

3. Start writing with the brush pen.

4. Bridge the space between words with overlaying flourishes.

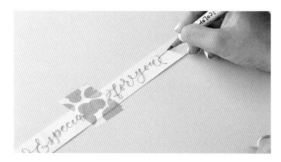

5. Once you've written up to the point where the ribbon is temporarily secured with tape, reposition the masking tape and continue writing.

6. Once dried, it's complete. If you put a cloth over it and iron, it becomes less likely to fade when washed.

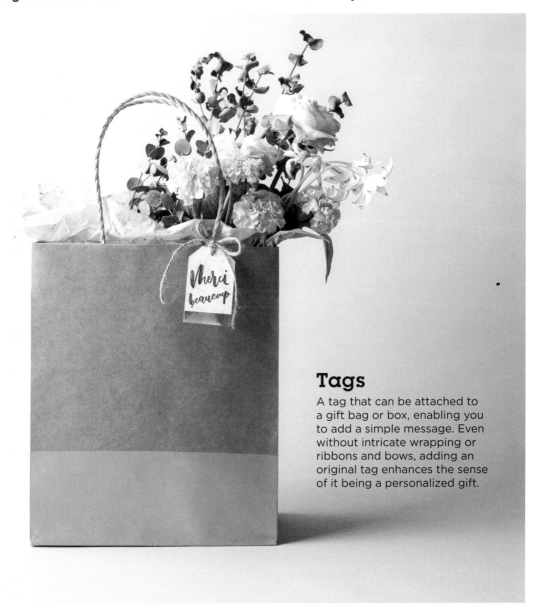

Tags

A tag that can be attached to a gift bag or box, enabling you to add a simple message. Even without intricate wrapping or ribbons and bows, adding an original tag enhances the sense of it being a personalized gift.

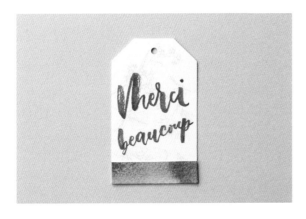

TIP

Write a message on the tag and tie it to the handle of a paper bag with hemp twine. The green underline is made by cutting paper colored with a dye-based brush pen and a water brush (refer to page 80) and gluing it on.

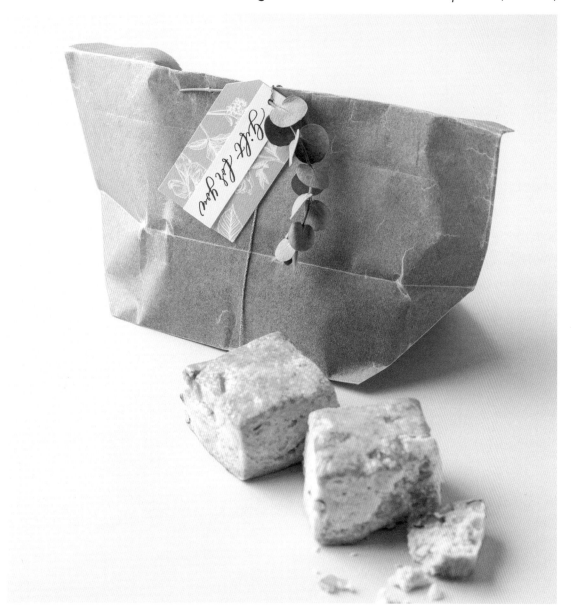

TIP

Cut a white paper according to the length of the tag and write your message. Overlay it on the tag, punch a hole with an awl, thread the hemp twine through and it's complete. It's convenient to use even for small gift-giving.

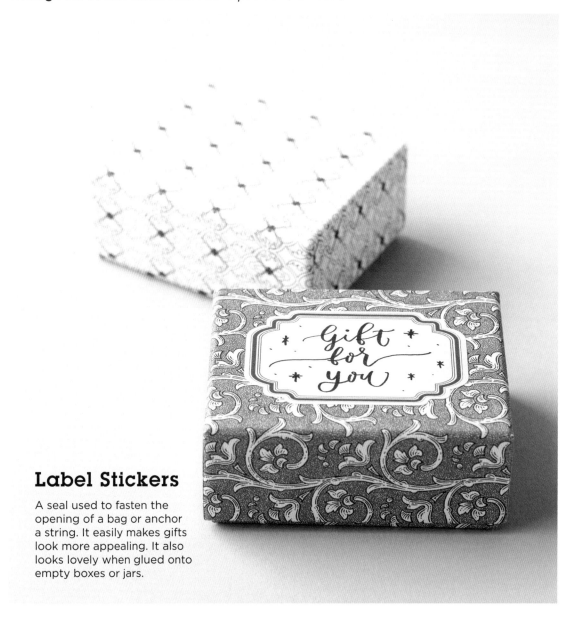

Label Stickers

A seal used to fasten the opening of a bag or anchor a string. It easily makes gifts look more appealing. It also looks lovely when glued onto empty boxes or jars.

TIP

Write letters on the sticker and draw dots and sparkles around it. Sketching a center guide line ensures even spacing. The elongated flourishes on the word "for" is a highlight.

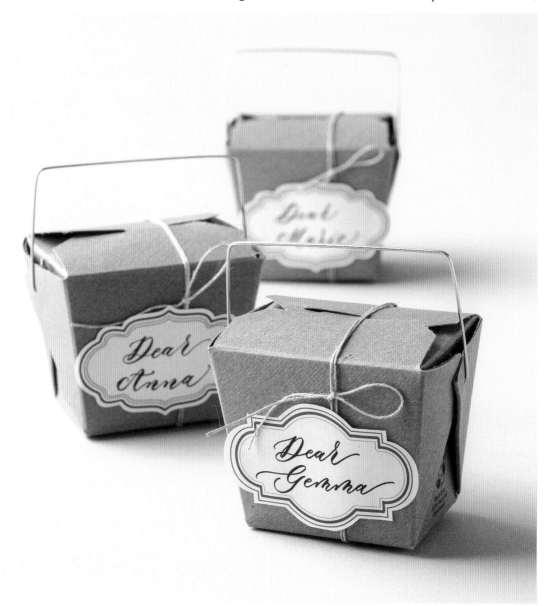

TIP

A label sticker with the recipient's name written on it. Even if the number of letters in the name varies, by writing "Dear" centered and adjusting the width of the name with flourishes, you can achieve a unified design.

afterword

Conclusion

I would be delighted if everyone who reads this book is filled with inspiration, thinking, "I can't wait to try this!" or "I love this color combination!"

In Japan, the act of writing calligraphic characters is filled with significance. When you deliver a letter or card to someone, they know you wrote it while thinking about them. And when the characters are beautifully rendered, the writing is all the more meaningful.

The desire to write and the sheer love of it, I believe, become the driving forces for improvement. As you admire the work of many other modern calligraphers and think, "I wish I could write like this," please take that thought as your cue to pick up a pen and practice.

Whether it's early in the morning, a break between housework or chores, a brief moment before a meeting or as you wind down before bed, I hope you'll continue to enjoy the world of modern calligraphy for as long as you have paper and pens.

— **Maki Shimano**

"Books to Span the East and West"

Tuttle Publishing was founded in 1832 in the small New England town of Rutland, Vermont [USA]. Our core values remain as strong today as they were then—to publish best-in-class books which bring people together one page at a time. In 1948, we established a publishing outpost in Japan—and Tuttle is now a leader in publishing English-language books about the arts, languages and cultures of Asia. The world has become a much smaller place today and Asia's economic and cultural influence has grown. Yet the need for meaningful dialogue and information about this diverse region has never been greater. Over the past seven decades, Tuttle has published thousands of books on subjects ranging from martial arts and paper crafts to language learning and literature—and our talented authors, illustrators, designers and photographers have won many prestigious awards. We welcome you to explore the wealth of information available on Asia at **www.tuttlepublishing.com.**

Published by Tuttle Publishing, an imprint of
Periplus Editions (HK) Ltd.

www.tuttlepublishing.com

ISBN: 978-0-8048-5771-0

FUDE PEN DE HAJIMERU MODERN CALLIGRAPHY
Copyright © 2019 Maki Shimano
Originally published in Japan by Sekaibunka Holdings Inc.
English translation rights arranged with Sekaibunka Holdings Inc.
through Japan UNI Agency, Inc., Tokyo

English translation © 2024 Periplus Editions (HK) Ltd
Page 14 bottom right: Vinokurov Alexandr/Shutterstock.com

28 27 26 25 24 10 9 8 7 6 5 4 3 2 1
Printed in China 2402EP

Distributed by

North America, Latin America & Europe
Tuttle Publishing
364 Innovation Drive
North Clarendon,
VT 05759-9436 U.S.A.
Tel: (802) 773-8930
Fax: (802) 773-6993
info@tuttlepublishing.com
www.tuttlepublishing.com

Asia Pacific
Berkeley Books Pte. Ltd.
3 Kallang Sector #04-01
Singapore 349278
Tel: (65) 6741 2178
Fax: (65) 6741 2179
inquiries@periplus.com.sg
www.tuttlepublishing.com